IMAGES
of Rail

CLEVELAND
MAINLINE RAILROADS

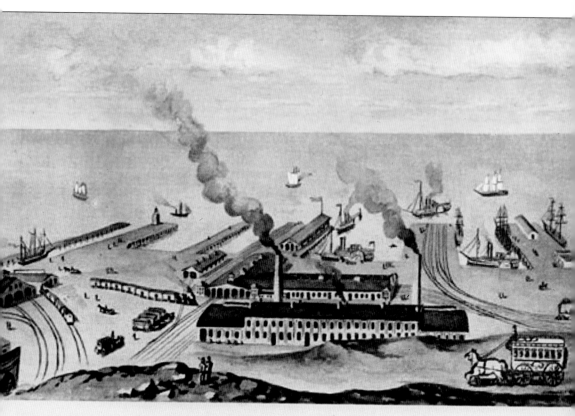

RAILWAY STATION AND DOCKS, 1854.

The first Cleveland Union Depot was built in 1854 at the foot of a hill where Bank (West Sixth) and Water (West Ninth) Streets met by the Lake Erie shore. It cost $75,000 to build and consisted of several wooden sheds. Its location enabled passengers to make easy transfers between trains and boats. Shown is the depot in an 1854 image that was originally a woodcut print. (Cleveland State University Library Special Collections.)

ON THE COVER: The Euclid Railroad was incorporated in 1883 to build a spur from the New York, Chicago & St. Louis Railroad (NYC&St.L) to stone quarries west of Green Road in Euclid Township. The line, built between 1883 and 1884, was nearly a mile and a half. Motive power was furnished by the NYC&St.L. Two crew members ride the front of a locomotive on the spur on August 30, 1950. (Cleveland State University Library Special Collections.)

IMAGES
of Rail

CLEVELAND
MAINLINE RAILROADS

Craig Sanders

ARCADIA
PUBLISHING

Published by Arcadia Publishing
Charleston, South Carolina

Printed in the United States of America

Library of Congress Control Number: 2013944812

For all general information, please contact Arcadia Publishing:
Telephone 843-853-2070
Fax 843-853-0044
E-mail sales@arcadiapublishing.com
For customer service and orders:
Toll-Free 1-888-313-2665

Visit us on the Internet at www.arcadiapublishing.com

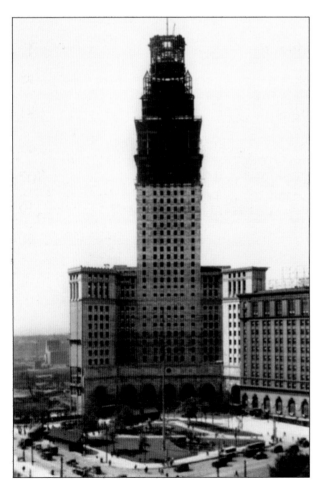

One of Cleveland's best-known landmarks is Cleveland Union Terminal (CUT), located on Public Square. Excavation began in 1924, and the station opened to rail traffic on October 23, 1929. The 708-foot Terminal Tower was the tallest building in the world outside of New York City until 1967. It is shown under construction on August 2, 1927. The CUT complex also included a hotel, department store, and post office. (Cleveland State University Library Special Collections.)

CONTENTS

ACKNOWLEDGMENTS

Cleveland Mainline Railroads is a look at the intercity railroads that served Cleveland during the first half of the 20th century. Although some images in this book were made before 1900, the majority of the photographs were recorded between the turn of the 20th century and the late 1960s. This time period represents the golden era of railroading in America when train travel was a far larger part of everyday life for many, and much of the nation's freight moved by rail, even if trucks were needed to take it to or from most final destinations.

By design, this book does not cover the industrial and short-line railroads that operated within Cleveland during the time period covered. Those railroads served Cleveland's robust industrial base and worked hand in hand with the mainline railroads in switching and interchanging freight. The industrial railroads are deserving of a history of their own.

Most of the images in this book are from the Bruce Young Collection of the Michael Schwartz Library's Special Collections at Cleveland State University. I never met Mr. Young, a retired teacher who died in 2003 and willed his considerable collection of railroad photographs and literature to the university. We are all richer for his generosity.

Other images came from the Cleveland Press, Cleveland Union Terminal, and Herbert Harwood Collections. Mr. Harwood graciously allowed me to use several of his images.

Robert Farkas readily agreed to provide photographs that he took in the late 1960s, which filled a gap in my coverage of the early years of the Penn Central Railroad.

I wish to thank for their assistance William Barrow, the special collections librarian; Lynn Duchez Bycko, special collections associate; and Mary Margaret Schley, my editor at Arcadia Publishing.

Finally, this book would not have been possible without the assistance and support of my wife, Mary Ann Whitley, who copyedited the manuscript and provided encouragement throughout this project. The responsibility for any errors or omissions lies solely with the author.

INTRODUCTION

Take out a map of the eastern United States and draw a line between Chicago and New York. About halfway between America's two historically largest business and population centers lies Cleveland.

Cleveland's location within the Chicago–New York transportation corridor proved beneficial for the development of railroads, highways, and air-travel routes, prompting civic leaders to proclaim Cleveland one of the best-served places in the nation. Transportation helped make Cleveland one of the top four centers of industry and commerce—the others being Chicago, Detroit, and Milwaukee—in the former Northwest Territory. Railroads played an essential role in enabling Cleveland to become Ohio's largest urban area and one of America's most influential cities.

The city is named for Gen. Moses Cleaveland, one of seven directors of the Connecticut Land Company and head of a survey party that, on July 22, 1796, laid out a village on the east bank of the Cuyahoga River on a bluff overlooking Lake Erie. Cleaveland envisioned the site as the capital of the Western Reserve of Connecticut. He returned to Connecticut in October 1796 and never again visited his namesake city. The village of Cleaveland was incorporated on December 23, 1814.

How the letter *a* came to be dropped from "Cleaveland" and by whom has never been definitively determined. By one account, the phrase "City of Cleveland" without the letter *a* appeared on a field survey map drawn in 1796. Another account has it that a newspaper dropped the *a* in order to fit the city's name into its nameplate after receiving a shipment of paper that was smaller than what the publisher had been using. Versions of that account differ as to whether it was the *Cleaveland Advertiser* or the *Cleaveland Herald*.

Historian James Harrison Kennedy suggested in *A History of the City of Cleveland* that the letter *a* in the type used by the *Herald* to form "Cleaveland" became damaged and was removed because replacement type was not available. For unexplained reasons, the *a* was never replaced in the city name in the masthead. This occurred between April 12 and June 8, 1833, and the paper size of the publication had not changed during that period.

Jon C. Teaford, author of *Cities of the Heartland*, observed that early-19th-century heartland residents knew that if they wanted to prosper and engage in global trade, they needed transportation links with Atlantic and Gulf of Mexico ports. Therefore, the largest heartland cities in the early 19th century were located on the Ohio and Mississippi Rivers. Cincinnati was Ohio's undisputed top urban center, while Cleveland was a sleepy backwater of a mere 50 homes.

The 1825 opening of the Erie Canal in New York State meant that cities along the Great Lakes could compete with those on the Ohio and Mississippi Rivers to become commerce conduits to the Mid-Atlantic seaboard. The Erie Canal provided an all-water route between Lake Erie and the Hudson River via Buffalo and Albany, New York. Lake Erie cities were closer to Mid-Atlantic cities and ports than were the cities located along the Ohio River. This proximity gave the lake cities an advantage during the railroad-development era.

Cleveland also benefited from being on the Ohio & Erie Canal between Lake Erie and the Ohio River. Built by the state between 1825 and 1832, Cleveland was made the canal's northern terminus as a result of political maneuvering by Cleveland attorney and state representative Alfred Kelley. That triggered howls of protest from civic leaders in Sandusky, which was vying with Cleveland and Toledo to become the premier Lake Erie port and which wanted to be the terminus of the Ohio & Erie Canal.

The placement of the canal on the east side of the Cuyahoga River ensured that Cleveland, and not Ohio City on the river's west bank, would become the region's focus of commerce. The two communities briefly fought a "bridge war" over the 1837 building of a bridge across the Cuyahoga. Gunshots were fired, and stones thrown, but no fatalities occurred. The two sides eventually made peace, and Cleveland annexed Ohio City in 1854.

By 1840, more than 60 steam-powered vessels plied the Great Lakes, most of them calling at Cleveland. But Cleveland still lagged behind Cincinnati in size and wealth. The 1840 census showed that the two largest heartland cities were Cincinnati (46,338) and St. Louis (16,469). With 6,071 inhabitants, Cleveland was the fourth-largest heartland city, but it was approximately the same size as Columbus (6,048) and Dayton (6,067) and was not much larger than Zanesville (4,768), Steubenville (4,247), and Chillicothe (3,977). The coming of the railroad helped change that. Clevelanders recognized as early as the 1820s the importance of attracting railroads, but railroad development in Cleveland trailed efforts elsewhere in the state.

Ohio's first railroad was the Erie & Kalamazoo Railroad, which opened in 1836 between Toledo and Adrian, Michigan. A trip over the 33-mile line took three hours. Cleveland's first rail operation was the Cleveland & Newburgh Railway, which was chartered by the Ohio legislature on March 3, 1834. Built with oak rails and ties, the line used gravity to propel cars loaded with stone and logs from the top of Cedar Hill to Euclid Avenue, where horses took over for the trip to the south side of Public Square.

Passenger service began on July 4, 1835, featuring two round-trips a day for 25¢ between the Billings Hotel, located at 101st Street and Euclid Avenue, and the Cleveland Hotel on the southwest corner of Public Square. Service rose to six daily round-trips, but the line was losing money, and its owner went bankrupt in 1840. Cuyahoga County kept the service going with a $48,866 subsidy, but the line continued to lose money and was abandoned in 1842.

In the meantime, a number of fanciful plans to build railroads to Cleveland surfaced, but none of them panned out. These included the Great Western Railroad, which, according to an 1829 published plan, would originate in New York City and extend to the Mississippi River, following the southern rim of Lake Erie. The cost of building the 1,050-mile line was estimated at $15 million, but no work was ever completed.

An 1837 financial panic stalled railroad development throughout the state. Through the end of 1836, the Ohio legislature had issued 47 railroad charters, but four years later the state had just 40 miles of track. Investors viewed railroads as risky enterprises. Some railroads tried to overcome investor reluctance by taking advantage of the Ohio Loan Law of 1837, which authorized the state to make loans equal to a third of a project's cost provided that the business receiving the loan had already raised capital to cover two-thirds of the cost. But the law was filled with loopholes that allowed entrepreneurs to obtain loans without having raised much, if any, cash.

Such was the case with the Ohio Railroad (OR), which had been organized on April 25, 1836, in Painesville with the intent of building a 177-mile railroad on a double row of piles upon which planks would be placed to hold the tracks. The route would approximate the never-built Great Western between the Pennsylvania border and the Maumee River in Toledo. Many OR stockholders had conditionally deeded land in lieu of cash, and the state of Ohio loaned the OR $249,000. The railroad went bankrupt in 1843, and only 63 miles of wood superstructure laid on piles were constructed, some near the Cuyahoga River.

Altogether, six railroads received more than $717,000 in loans, with only one company—the Little Miami Railroad—ever repaying its loans in full. Although the loans stimulated the construction of 204 miles of track, none of that track was located in Cleveland. The closest railroad to Cleveland

had been the Painesville & Fairport Railroad (P&F). Incorporated on February 10, 1835, it opened four miles of track in 1838 in neighboring Lake County. The P&F received $6,182 in loans from the state of Ohio but went bankrupt in 1845 and never repaid the funds.

The loan law was dubbed the "Plunder Law" because the state had loaned more money than it had in its treasury, forcing it to borrow to meet expenses. By 1839, Ohio had a deficit of more than $250,000. Although state financial support of railroad development largely had failed, public support from cities and counties proved more successful in getting railroads built in Cleveland and throughout the state.

Cleveland's first operating intercity railroad was the Cleveland, Columbus & Cincinnati Railroad (CC&C). It was chartered on March 14, 1836, but an economic downtown the following year stymied its development for nearly a decade. Development resumed in 1847 after the City of Cleveland extended the CC&C a $200,000 line of credit, and private investors contributed $65,000. The City of Columbus also subscribed $50,000 to the CC&C.

Ground was broken in the Cleveland Flats and surveying and land acquisition began. A depot was constructed on the Cleveland lakefront near West Ninth Street. On November 3, 1849, the company's lone locomotive pulled a string of wooden flatcars into Cleveland along River Street. "The whistle of the locomotive will be as familiar to the ears of the Clevelander as the sound of church bells," commented the *Cleveland Herald.*

Alarmed that the CC&C's first train had operated at six miles per hour, the Cleveland City Council quickly adopted an ordinance limiting train speeds to between four and five miles per hour.

The CC&C built southwest from Cleveland, opening 36 miles of track to Wellington in Lorain County in July 1850. The line was completed to Columbus on February 21, 1851, with CC&C president Alfred Kelley driving the last spike at a ceremony in Iberia. Excursion trains operated that day between Cleveland and Columbus, and the next day, a parade and banquet were held in Cleveland to celebrate the line's completion. As part of the festivities, an excursion train was run over Cleveland's second railroad, the Cleveland & Pittsburgh Railroad (C&P).

The C&P received a charter on the same day as did the CC&C, March 14, 1836. Its founders intended to build from Cleveland southeastward toward the Ohio River and then to Pittsburgh. The C&P's development mirrored that of the CC&C, including being thwarted by a poor economy and seeking public assistance to get jump-started. In April 1847, Cleveland voters approved a $100,000 stock subscription to help pay for construction of the C&P.

The first operation on the C&P was the February 22, 1851, excursion over the 26 miles built to Hudson in Summit County. The excursion train, though, derailed on the return trip.

On March 4, 1852, the mayor of Cleveland, the entire city council, and others boarded a C&P train bound for Wellsville for a three-day celebration to commemorate the line reaching the Ohio River.

A third railroad opened in Cleveland in the 1850s to complete the first wave of the city's railroad development. The Cleveland & Mahoning Valley Railroad was chartered in 1848, but financial problems delayed its construction. It finally opened in 1856.

Pre–Civil War railroads typically were built only within individual states. Travelers and freight shipments going long distances had to make a series of connections. By the 1850s, some railroads had established alliances that evolved into trunk lines stretching from one region of the country to another. Early railroads also tended to be undercapitalized and subject to financial failures during the many depressions that plagued the 19th century. The history of many railroads is that of a series of trips to bankruptcy court, resulting in name and ownership changes as their financial fortunes ebbed and flowed. These roller coaster–like conditions gave further impetus to the establishment of trunk lines, which provided greater financial stability and operating efficiencies.

A third wave of railroad building occurred in the region in the 1870s and, by the late 1880s, resulted in four more railroads being built to Cleveland. Three of these were north-south routes that linked the city with the southern and southeastern parts of the state. The fourth railroad was located on a route between Chicago and Buffalo, New York.

By the turn of the 20th century, Cleveland's railroad operations were dominated by five trunk lines, four of which extended between the Atlantic seaboard and the dominant railroad-hub cities of Chicago and St. Louis. These were the New York Central System, the Pennsylvania Railroad, the Erie Railroad, the Baltimore & Ohio Railroad (B&O), the New York, Chicago and St. Louis Railroad (better known as the Nickel Plate Road), and the Wheeling & Lake Erie Railroad. These lines were household names for more than half of the 20th century, as Cleveland's railroads remained relatively stable.

But changes that began in 1949 resulted in the names of most of these well-known railroad companies vanishing into history as mergers and route abandonments took place. By the end of the 1960s, every railroad that had served Cleveland at the end of World War II had merged with or been acquired by another railroad.

The first substantial change was the lease of the Wheeling & Lake Erie by the Nickel Plate Railroad (NKP) in late 1949. The Erie merged with the Delaware, Lackawanna & Western Railroad (DL&W) in October 1960 to form the Erie Lackawanna Railroad (EL). In 1962, the Chesapeake & Ohio Railway (C&O) obtained stock control of the B&O, although the latter continued to operate under its own name until the 1973 formation of the Chessie System, which controlled and operated the B&O and the C&O under the Chessie name.

In 1964, the Norfolk & Western Railway merged with the NKP and began operating under the N&W name. The NYC and PRR began discussing a merger in the late 1950s, and this union was finally consummated in February 1968 with the formation of the Penn Central Transportation Company (PC). The merger did not go well, and in June 1970, the PC filed for bankruptcy protection.

The Cleveland railroad scene changed further in the 1970s when the PC and EL were folded into the Consolidated Rail Corporation (Conrail), an entity created by Congress to take over operations of seven bankrupt Northeastern railroads. Conrail had a mandate to shed lightly used and unprofitable branchlines as well as redundant mainline routes. By the 1970s, the industrial base whose transportation needs had sustained Northeastern railroads for decades had diminished greatly; factories closed in droves, and railroads had far less freight to haul. Railroads also suffered when trucks began hauling a larger share of business that once moved by rail.

During the Conrail era, Cleveland remained an important railroad hub. Conrail focused much of its efforts to build an X-shaped route with one leg extending from Boston to St. Louis and the other from the Mid-Atlantic region to Chicago. At the center of the "X" was Cleveland.

Norfolk Southern Railway (NS), which included the former N&W, and CSX Transportation, which included the former Chessie, vied in the late 1990s to gain control of Conrail. The two companies eventually agreed to split Conrail, with CSX gaining most of the former Boston–St. Louis corridor and NS gaining the former Mid-Atlantic–Chicago corridor.

Nearly all of the railroad routes that served Cleveland through the 1960s are still in existence today, although not all of them are still used for through traffic as they once were.

One, a Cleveland–Brady Lake, Ohio, route used by the NYC, has been abandoned in its entirety. Much of the former Erie in Cleveland proper is still used, although portions of it have been abandoned, particularly east of Cleveland.

The former B&O line between Cleveland and Akron is still in use, although most of this route is now owned by the National Park Service and used by the Cuyahoga Valley Scenic Railroad between Independence and Akron. The other former B&O line to Cleveland is operated by CSX. The former mainlines of the PRR, NKP, and NYC are all major freight routes of NS and CSX, with both still doing a substantial freight business in Greater Cleveland.

The Cleveland Line of the original Wheeling & Lake Erie (W&LE) is operated by a regional railroad, also named W&LE, that came back to life in 1990 when NS spun off some former W&LE lines in Ohio. A portion of the original W&LE Cleveland Line is today operated by the Cleveland Commercial Railroad, which also operates under lease from NS some former Erie trackage in Cleveland.

One

BALTIMORE & OHIO RAILROAD

The Baltimore & Ohio Railroad had two Cleveland routes, both of which were built to haul coal from southeastern Ohio. The Lake Shore & Tuscarawas Valley Railway (LS&T) was incorporated on July 2, 1870, to build between Berea and a connection in Tuscarawas County with the Pittsburgh, Cincinnati & St. Louis Railroad (later PRR). Instead, the LS&T built between Elyria and Uhrichsville and acquired eight miles of the Elyria & Black River Railway between Elyria and Black River (Lorain). The line was completed in August 1873.

Beset with financial troubles, the LS&T was reorganized on February 5, 1875, as the Cleveland, Tuscarawas Valley & Wheeling Railway (CTW&W). Two years later, it announced plans to build from Uhrichsville to Bridgeport on the Ohio River opposite Wheeling, West Virginia. That extension was completed in 1880, and on March 1, 1883, the CTV&W was renamed the Cleveland, Lorain & Wheeling Railroad (CL&W).

The Cleveland & Southwestern Railway (C&S) was incorporated on April 25, 1887, to build from Cleveland to Zanesville. The C&S had built 30 miles to Medina when it consolidated with the CL&W on May 11, 1893. This gave the CL&W direct access to Cleveland. The B&O purchased a majority of the stock of the CL&W in March 1901 and assumed operational control in 1909.

The other B&O route to Cleveland began with the August 21, 1871, organization of the Valley Railway, which intended to build between Cleveland and Wheeling via Akron and Canton. Construction began in 1873 but halted a year later during an economic depression. Work resumed in 1878, and the Valley opened to Canton on February 1, 1880, and to Valley Junction on January 1, 1883. Rather than continue building to Wheeling, the Valley worked out a trackage-rights arrangement with the Wheeling & Lake Erie Railway to access Wheeling.

The B&O acquired an interest in the Valley in January 1890 in order to tap the lucrative Cleveland freight market. After the Valley went into receivership in 1894, it was sold on September 10, 1895, to the Cleveland, Terminal & Valley Railroad (CT&V), a B&O subsidiary. The B&O began operating the CT&V in June 1909.

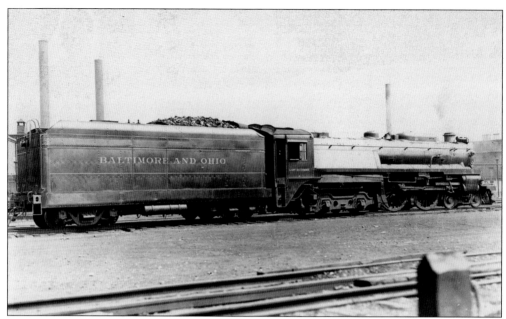

No. 1 was the *Lady Baltimore*, which was the B&O's sole J-1–class locomotive and the second 4-4-4 steam engine built in the United States. The Jubilee-type engine was created by the B&O in 1934 by rebuilding an existing 4-4-2 Atlantic-type engine. Designed to haul lightweight passenger trains, No. 1 was assigned to pull the *Abraham Lincoln* on the Alton Railroad, a B&O subsidiary operating between Chicago and St. Louis. Although built for speed, the *Lady Baltimore* did not perform well on the flat and straight Alton. In the late 1930s, No. 1 briefly was assigned to Cleveland-Wheeling, West Virginia, Nos. 58 and 59, operating only as far south as Holloway, Ohio, because it could not climb the grades from Holloway to Lafferty, Ohio. These trains operated on a daytime schedule and were steam powered except for periodic assignments of gas-electric cars. (Both, Cleveland State University Library Special Collections.)

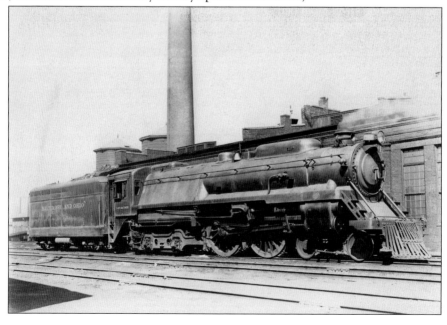

The *Lady Baltimore* could only handle two cars on the Cleveland-Wheeling run—a coach and a baggage car. It may have needed a helper locomotive to get up the loop line at Akron Junction. The B&O wanted to discontinue the trains in 1942, but Nos. 58 and 59 received a service upgrade instead. The last passenger trains to operate over the former CL&W made their final trips on September 29, 1951. (Cleveland State University Library Special Collections.)

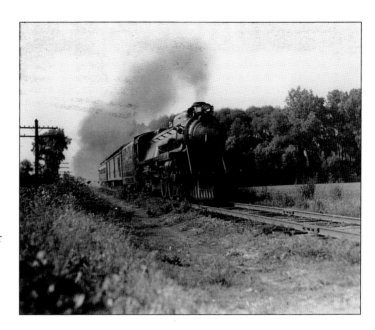

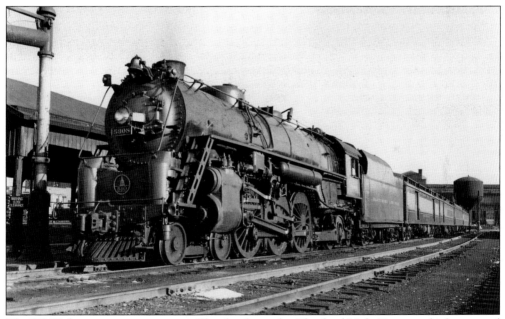

The B&O's last passenger service in Cleveland was the *Cleveland Night Express*, which operated on an overnight schedule between Cleveland and Baltimore. Assigned diesel locomotives in September 1951, by 1962, Nos. 17 and 18 averaged 30 passengers a day between Cleveland and Washington, DC. In its latter years, the train typically carried a baggage/lounge car, a coach, and a sleeper. It began its final trips on January 4, 1963. (Cleveland State University Library Special Collections.)

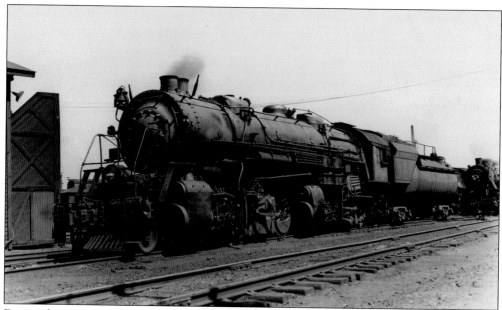

During the 1950s, larger steam locomotives worked the former CL&W line to Lorain and the Lake Branch to Fairport Harbor. Whereas two Q-class Mikados usually were needed to pull a 130-car train, one Consolidation Mallet–type engine could handle the same train, cutting in half the number of locomotives and crews needed. Above, B&O No. 7158 awaits its next assignment. This engine was part of an order built by Baldwin as an EL-5–class locomotive between 1919 and 1920. Some of those locomotives were rebuilt starting in 1927 into the EL-5a class. The driver wheels on these 2-8-8-0 locomotives made them well suited to lugging heavy trains over hilly terrain. Below, the crew of No. 7146, another EL-5a, leans out to look at the photographer. These locomotives were retired in the early 1950s. (Both, Cleveland State University Library Special Collections.)

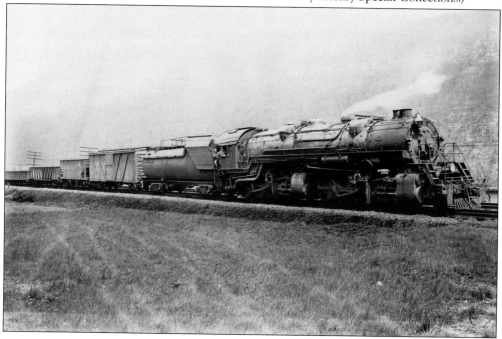

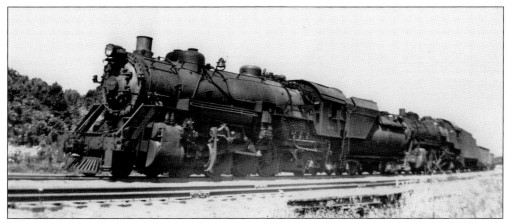

Two Q-class locomotives were assigned to pull 130 hopper-car trains between Lorain and Holloway on the former CL&W. Q-3–class No. 4508 leads a train through Lester, where the B&O routes from Cleveland and Lorain came together. The route continued south to Sterling via the Medina Cutoff where it joined the B&O's Chicago-Pittsburgh mainline. A branch diverged at Lester that ran through Medina. (Cleveland State University Library Special Collections.)

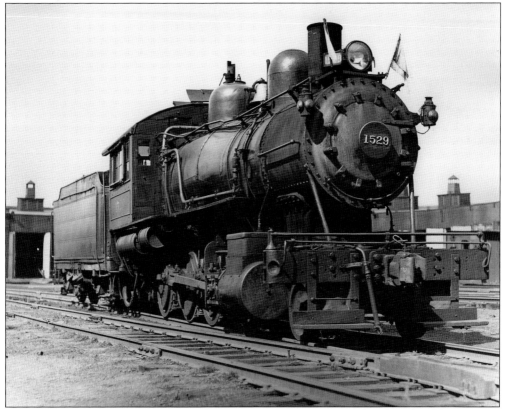

After taking control of the CL&W and the CT&V, the B&O consolidated yard and locomotive-service facilities in Cleveland at Clark Avenue Yard. This resulted in the closing of the CL&W and CT&V roundhouses and the opening of a new roundhouse at West Third Street. Clark Avenue passed over the B&O yard on a bridge. Shown at the roundhouse on June 8, 1939, is No. 1529. (Cleveland State University Library Special Collections.)

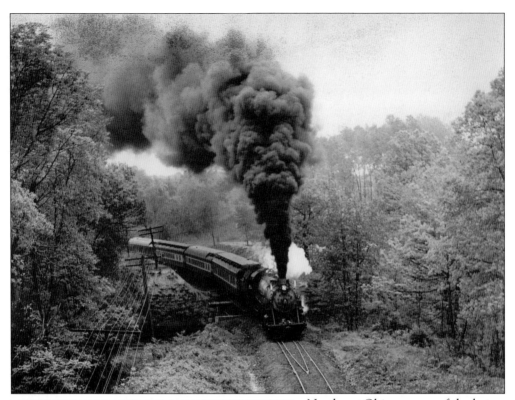

Northeast Ohio was one of the last bastions of steam locomotives on the B&O, and by late 1957, members of the Cleveland Railroad Club recognized that it would be a matter of months or weeks before steam power was phased out. They set about organizing a last run behind a steam locomotive that would travel from Cleveland to Holloway and return on May 17, 1958. However, the trip almost did not come about; B&O sidelined the last of its steam fleet earlier than expected, and railroad officials claimed that no serviceable steam locomotives were available. In desperation, the club wrote to W.C. Baker, B&O vice president of operations, who arranged for Q-4 No. 421 to pull the trip. The 13-car trip departed Cleveland on a Saturday morning with R.L. "Bob" Mace as the engineer and Lou Surace as the fireman. (Both, Cleveland State University Library Special Collections.)

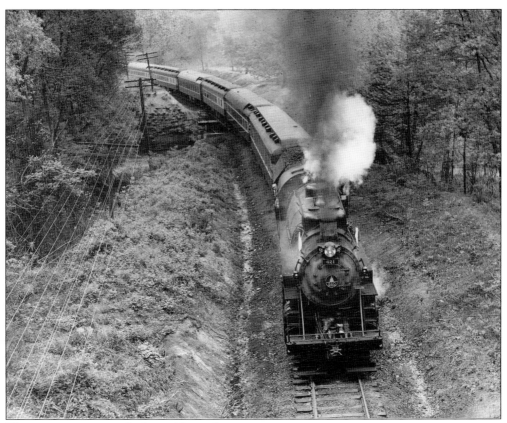

The excursion train picked up additional passengers at Berea and Lester. It made three photography stops en route. An adult ticket was $7 in advance, $8 aboard the train. During the layover at Holloway, passengers were able to explore the yard, and B&O officials posed EM-1 No. 675 and S-1a No. 524 along with various diesel locomotives. The air was filled with diesel horns being sounded by children who had climbed into the locomotive cabs. The train departed Cleveland at 8:30 a.m. and returned 12 hours later. It was the last over-the-road steam-operated train on the B&O, although some steam locomotives performed switcher duty, and No. 421 and others did stationary-boiler service. No. 421 was retired in November 1959 and subsequently scrapped. All photographs on pages 16 and 17 show the excursion train in Cleveland. (Both, Cleveland State University Library Special Collections.)

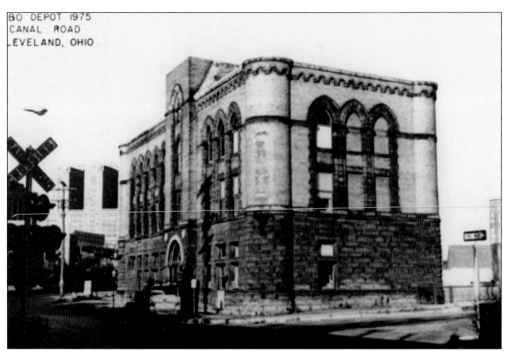

The CT&V opened this passenger station on Canal Street in Cleveland in 1898. The structure's clock tower and original roof were destroyed by fire. All B&O passenger trains serving Cleveland used this facility until shifting to CUT in June 1934. The B&O continued to have offices here until the 1970s. The depot still stands and is owned by Sherwin Williams Company. (Cleveland State University Library Special Collections.)

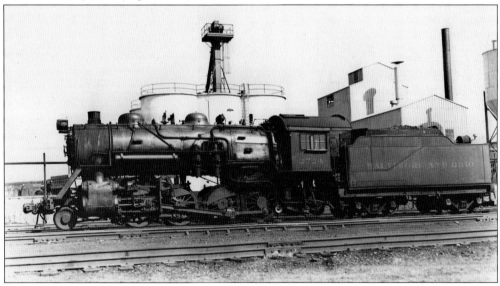

Built in 1909 by the American Locomotive Company (Alco), B&O No. 2724 already had rolled up many miles when this photograph was taken in the 1930s at West Third Street in Cleveland. Developed in 1866, the Consolidation-type locomotive was a primary hauler of freight and passenger trains on many railroads but was relegated to secondary freight-hauling duties when larger and more powerful locomotives came along. (Cleveland State University Library Special Collections.)

The B&O replaced steam locomotives with diesel locomotives throughout the 1950s, but the process was not complete on its Northeast Ohio routes until late 1957. A few steam locomotives were stored in ready-to-run condition but never pulled a train. This included No. 405, which was pressed into service in early January 1959 to provide steam for the Clark Avenue Yard office after the regular heating system failed. (Cleveland State University Library Special Collections.)

Coal was a primary commodity handled by the B&O in Northeast Ohio. The black diamonds reached Cleveland via both B&O routes. Much of the Cleveland-bound coal was consumed by the city's steel mills located along the Cuyahoga River. Jones & Laughlin Steel was on the west bank, while Republic Steel was on the east bank. Some coal was loaded onto lake freighters at Lorain and at Fairport Harbor. (Cleveland State University Library Special Collections.)

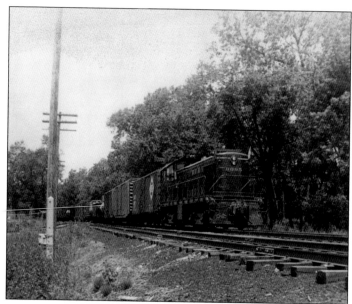

In the early 1970s, three local freights and ten yard crews were assigned to Clark Avenue Yard, the B&O's main Cleveland classification yard. Some locals went as far as Lester and Akron. Shown pulling a train of general merchandise in Cleveland is No. 9095, an American Locomotive Company (Alco) S-4. These locomotives were used primarily for switching duties and worked in yards or on local freight trains. (Cleveland State University Library Special Collections.)

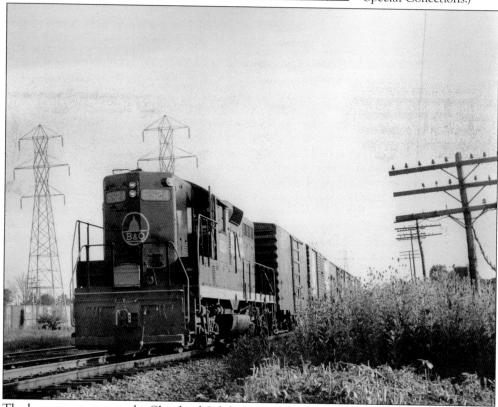

The largest customer on the Cleveland Subdivision of the former CL&W was a General Motors parts plant in Parma. The B&O had an eight-track yard there to handle the considerable rail traffic generated at the plant. Between Parma and RD Tower, the B&O once served 30 customers. Here, a lone GP9 diesel locomotive pulls a string of boxcars near Brookpark Road in Parma, which is Cleveland's largest suburb. (Cleveland State University Library Special Collections.)

Two

ERIE RAILROAD

The Cleveland & Mahoning Valley Railroad (C&MV) was Cleveland's third railroad. Chartered on February 22, 1848, the C&MV was not incorporated until 1851. At its first stockholders meeting, held in Warren on June 1852, it reported stock subscriptions of $500,000 and ordered route surveys to be made between Cleveland and Youngstown. The C&MV purchased land in Cleveland and surveyed various routes before settling on one that passed through Solon, Aurora, Mantua, Leavittsburg, and Warren. The line opened to Youngstown in 1856, but competing railroads pressured the Pennsylvania legislature into refusing to grant the C&MV authority to build an extension into that state. In 1865, the C&MV extended its tracks from Youngstown to the Pennsylvania border to connect with the Westerman Coal & Iron Railroad, which had built from Sharon, Pennsylvania, to the state line.

The C&MV was leased by the Atlantic & Great Western Railroad (A&GW) in October 1863. The A&GW was a broad-gauge (six feet) railroad line between a connection with the Erie Railroad at Salamanca, New York, and Dayton, Ohio, that opened in June 1864. However, the C&MV was a standard-gauge line, so a third rail was added to the C&MV tracks to enable cars from the A&GW to reach Cleveland beginning in November 1863.

Between 1867 and 1896, the A&GW endured a series of receiverships and name changes. The C&MV resumed independent operation and was reorganized on August 14, 1872. It had 131 miles of track, which included the mainline between Cleveland and Hubbard via Youngstown, and branches between Girard and Hazelton, and Niles and Lisbon.

The Erie had played a major role in the financial reorganizations of the A&GW, leasing it at times. On January 14, 1880, the A&GW was sold at a foreclosure sale and reorganized as the New York, Pennsylvania & Ohio Railroad. The Nypano, as the NYP&O was commonly called, leased the C&MV in 1880. The Erie leased the Nypano in 1883 and acquired all of its capital stock in 1896, and the Nypano operated as the New York, Lake Erie & Western Railroad between 1883 and 1895.

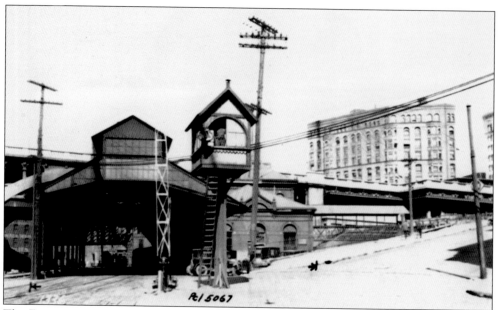

The Erie passenger station in downtown Cleveland was at Columbus and Canal Roads. Built by the Nypano in 1881, the station in the 1920s handled 20 passenger trains a day serving the Cleveland-Youngstown-Pittsburgh market. Through-coaches and sleepers for Jersey City, New Jersey, were interchanged at Warren or Youngstown with the Erie's Chicago Line trains. Erie passenger trains began using CUT in 1949. (Cleveland State University Library Special Collections.)

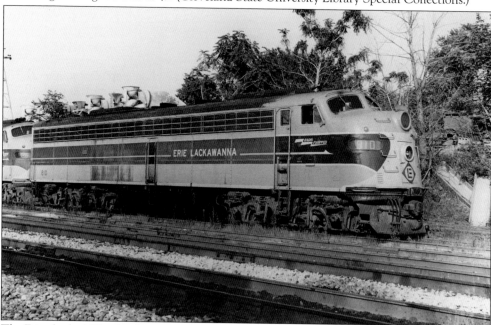

The Erie also had Cleveland passenger stations at East Fifty-fifth Street and East Ninety-third Street. Most trains stopped at both depots through the late 1940s, although some made conditional stops. After the Erie Lackawanna Railroad (EL) was folded in Conrail in April 1976, the Cleveland-Youngstown commuter trains continued to be pulled by former EL passenger locomotives, such as the one shown here, that still wore EL markings. (Cleveland State University Library Special Collections.)

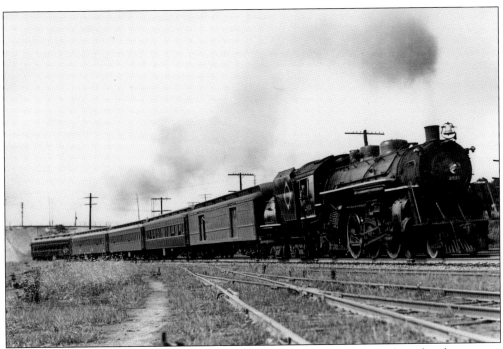

The Erie & Pennsylvania Railroad had a spirited competition in the Cleveland-Pittsburgh passenger market. The Pittsburgh & Lake Erie Railroad (P&LE) forwarded Erie trains east of Youngstown. About the time that the Erie began using CUT, it renamed one of its Cleveland-Pittsburgh trains the *Steel King* and cut its running time to two hours and forty minutes. By the early 1950s, the *Steel King* name had been applied to two more trains, thus forming the *Morning Steel King* and *Evening Steel King*. A Cleveland-Baltimore train, the *Washingtonian*, operated on the B&O east of Pittsburgh. In the photograph above, No. 2913, a 4-6-2–class K-2-A, pulls unnamed No. 626, an early afternoon train to Pittsburgh, on July 29, 1934. In the photograph below, No. 2943, a 4-6-2–class K-5-A, has the *Washingtonian* heading out of Cleveland on June 21, 1934. (Both, Cleveland State University Library Special Collections.)

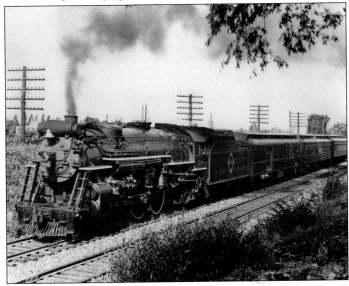

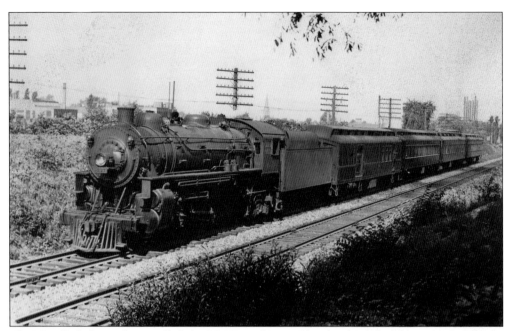

The New York Central controlled the P&LE, and Erie's Cleveland-Pittsburgh trains were shown in NYC timetables and used NYC-P&LE locomotives. Trains were scheduled to connect in Cleveland with NYC trains for Chicago and Detroit. Through early 1958, the Erie fielded two Cleveland-Pittsburgh round-trips and one Cleveland-Youngstown round-trip. The October 1, 1955, opening of the Ohio Turnpike eroded patronage. One pair of trains was discontinued in 1958, while the other pair continued in service through early 1964 before being discontinued. This left only Cleveland-Youngstown Nos. 28 and 29, a pair of commuter trains, on the EL's Cleveland Line. In the photograph above, NYC-P&LE No. 9227 pulls the *Washingtonian* past Harvard Avenue in Cleveland on June 15, 1934. In the photograph below, NYC-P&LE No. 9246 is pulling No. 685 into Cleveland on August 21, 1934. (Both, Cleveland State University Library Special Collections.)

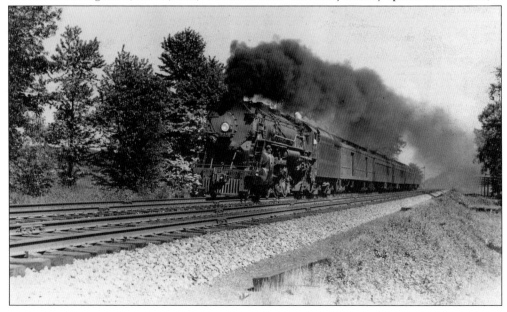

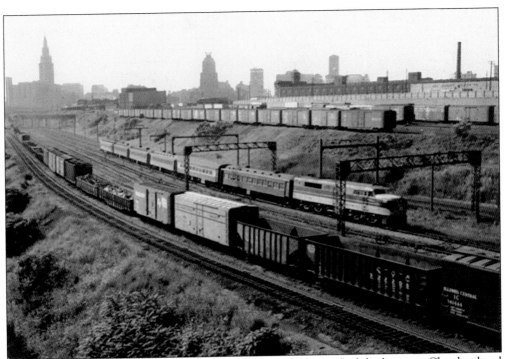

Nos. 28 and 29 operated on Monday-through-Friday commuter schedules between Cleveland and Youngstown. Patronage was sparse east of Aurora. The last passenger trains to use CUT, the EL wanted to end the trains, but the Ohio Public Utilities Commission refused to allow it in the face of widespread protests. Ridership nose-dived after Conrail closed the EL headquarters in Cleveland in 1976. The trains made their final trips on January 14, 1977, with E8A No. 4014 pulling three coaches. In their final years, the trains were limited to a top speed of 48 miles per hour. Above, No. 28 is at old Broadway Avenue in Cleveland in July 1965. Below, the train pauses at the Lee Road station, opened in 1948 to serve nearby Shaker Heights. (Above, photograph by Herbert Harwood; below, Cleveland State University Library Special Collections.)

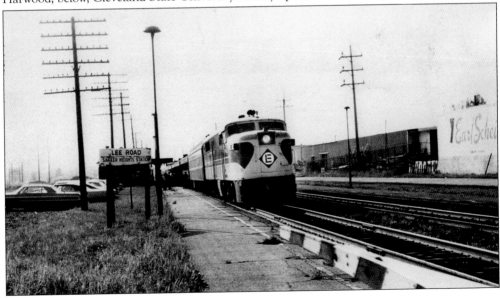

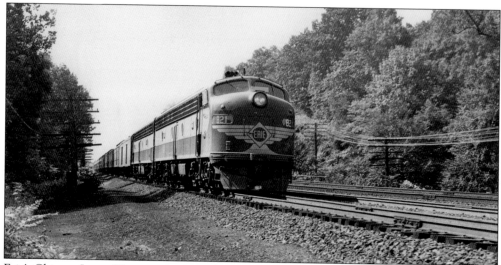

Erie's Chicago-Jersey City trains operated via Akron and Youngstown. Until the late 1950s, the Erie had a section of the *Lake Cities* that operated to Cleveland with through-coaches and sleepers from Jersey City. Through the 1960s, the EL continued to operate specials from Youngstown to Cleveland for baseball games and other events. This Erie passenger train has the two-tone green and yellow livery adopted for the streamliner era. (Cleveland State University Library Special Collections.)

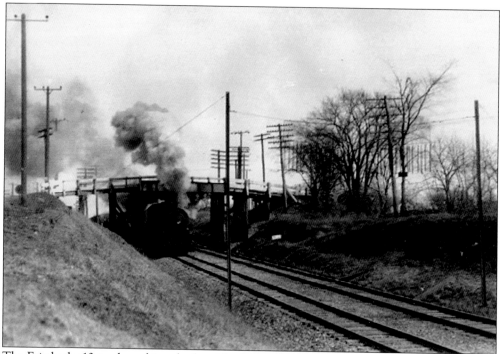

The Erie had a 10-track yard in suburban North Randall that was a staging point for locals that served more than 30 customers between Lee Road and Phalanx. In the 1960s, the EL based two locals here. The yard also was used to make up ore trains that were bound for steel mills in the Youngstown-Warren area and in Pennsylvania. Shown is a westbound train at North Randall in 1932. (Cleveland State University Library Special Collections.)

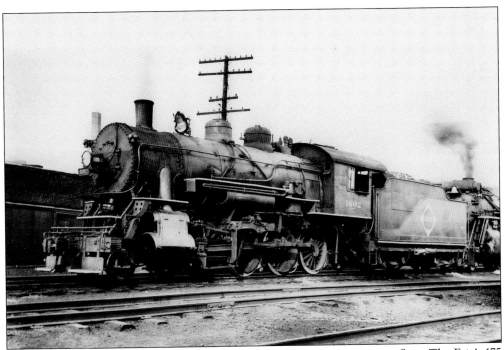

The H-21 class dominated the Erie's 2-8-0 Consolidation-type locomotive fleet. The Erie's 175 H-21 class locomotives were built between 1904 and 1906. Consolidation-type locomotives were widely used, with approximately 23,000 built for operation in the United States. The Erie began retiring some H-21 locomotives in 1927, but several continued in service through 1952. No. 1692 is shown in Cleveland on May 31, 1936. (Cleveland State University Library Special Collections.)

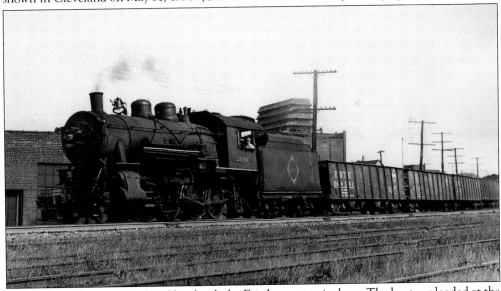

When the ore boats arrived in Cleveland, the Erie became quite busy. The boats unloaded at the Erie's River Bed Yard along the Cuyahoga River. River Bed was small, so cuts of loaded ore cars were moved 11 miles to North Randall Yard to be put together into Youngstown-bound trains. Shown with a set of hoppers is Consolidation-type No. 2016 at East Ninety-third Street on August 30, 1934. (Cleveland State University Library Special Collections.)

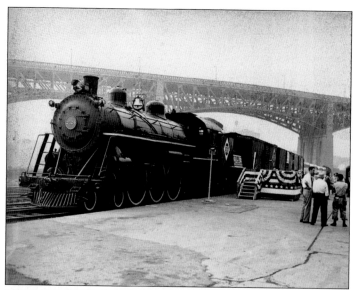

By November 1952, the Erie had finished replacing steam locomotives with diesels except in New York and New Jersey commuter-train service. The last Erie steam-locomotive operation occurred on March 17, 1954. That same year, the Erie donated a retired 4-6-2 Pacific to the American-Korean Foundation. It is shown here at a ceremony in the Cleveland Flats on July 3, 1954. (Cleveland State University Library Special Collections.)

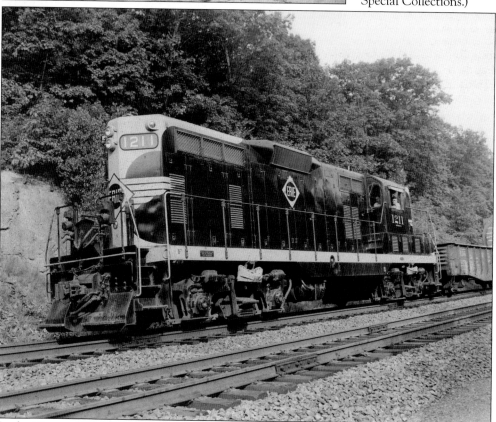

In the EL era, the Cleveland route saw 12 to 16 trains a day. Manifest freights operated between Cleveland and Brier Hill Yard in Youngstown and between Cleveland and Meadville, Pennsylvania. Although iron ore was shipped year-round, the ore boats only operated between April 1 and November 30. Shown is an Electro-Motive Division GP7 pulling a gondola. No. 1211 was bought by the Erie in 1950 but also served the EL. (Cleveland State University Library Special Collections.)

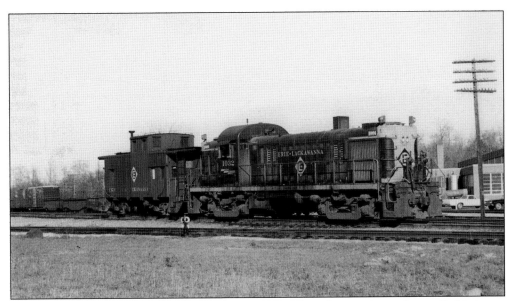

No. 1032 is an Alco RS-3 built for the Erie in 1950. These locomotives often pulled iron ore trains because of their lugging ability. Most empty ore trains from Youngstown turned back at North Randall, so these locomotives were used to take the hoppers to the River Bed Yard. These "drag down" jobs often returned light, with only a caboose in tow. This image was made in 1967. (Cleveland State University Library Special Collections.)

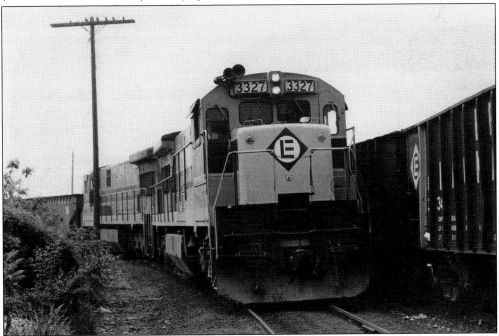

The Erie merged with the DL&W on October 17, 1960. The financially struggling carriers had parallel routes between Buffalo, New York, and New York Harbor; were both deeply in debt; and suffered heavy damage during a 1955 hurricane. The merger did not produce the intended benefits, and the EL went into receivership in 1972. Shown is EL 3327, a model U36C, in Cleveland in August 1975. (Cleveland State University Library Special Collections.)

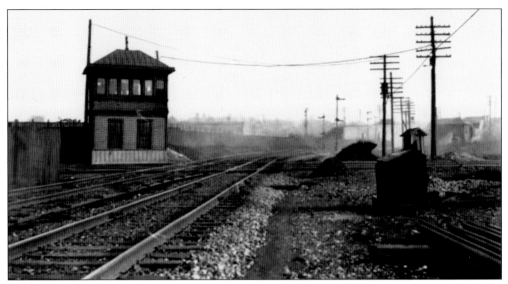

The Erie and PRR crossed at the grade at Erie Crossing. This c. 1921 view looks east along the Erie. The frame tower shown here was replaced in March 1941 by a redbrick structure owned by both railroads but operated by the PRR. That tower was destroyed by a freight derailment on February 15, 1977, and control of the crossing shifted to the PRR's Harvard Tower less than a mile west. (Cleveland State University Library Special Collections.)

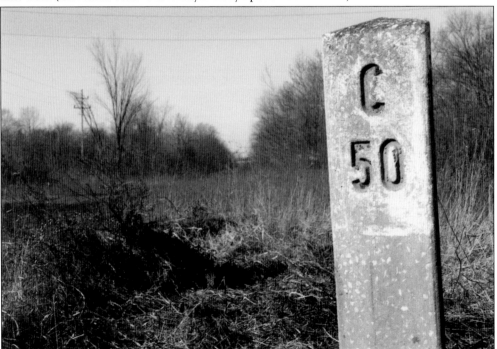

The bankrupt EL was folded into Conrail in 1976, but about half of the Cleveland-Youngstown route was abandoned in 1981. The last through train operated in 1980. The tracks are gone east of Chamberlain Road in Mantua Township, and the route between Solon and Mantua Township is inactive. Shown is a milepost measuring 50 miles from Cleveland next to the abandoned Erie right-of-way in Leavittsburg. (Photograph by Craig Sanders.)

Three

NEW YORK
CENTRAL SYSTEM

The New York Central System (NYC) was Cleveland's dominant railroad. The primary ancestors of the NYC in Cleveland were the Cleveland, Cincinnati, Chicago & St. Louis Railway (Big Four), and the Lake Shore & Michigan Southern Railroad (LS&MS).

The LS&MS, incorporated April 6, 1869, resulted from a series of mergers in the 1850s and 1860s. By August 16, 1869, it controlled a Chicago-Buffalo, New York, route via Cleveland and Toledo, Ohio, and Erie, Pennsylvania. Cornelius Vanderbilt and his New York Central and Hudson River Railroad (NYC&HR) gained stock control of the LS&MS in August 1877. The LS&MS maintained its own identity until merging with the NYC&HR on December 22, 1914.

Cleveland's first intercity railroad, the CC&C, had merged with the Bellefontaine Railroad on May 16, 1868, to form the Cleveland, Columbus, Cincinnati & Indianapolis Railroad (CCC&I), also known as the Bee Line.

Vanderbilt's son, William H. Vanderbilt, had invested in the first Big Four—the Cincinnati, Indianapolis, St. Louis & Chicago Railroad (CIStL&C)—which had formed on March 6, 1880. By the time of the CCC&I merger with the CIStL&C in June 1889, the Vanderbilts had stock control of the Big Four. The NYC leased the Big Four on February 1, 1930.

The LS&MS held ownership stakes in two other railroads that built routes in Cleveland. It held all of the stock in the Cleveland Short Line Company, incorporated on November 24, 1902, to build between Collinwood Yard and Rockport on Cleveland's southwest side. The route opened between Rockport and Marcy (9.73 miles) on February 24, 1910, and between Marcy and Collinwood (9.91 miles) on July 1, 1912.

The LS&MS was a half owner with the Pennsylvania Railroad of the Lake Erie and Pittsburgh Railway (LE&P), incorporated on April 29, 1903, to build between Lorain and Youngstown. The only portion of the LE&P ever built was a 27.79-mile section between Marcy and Brady Lake Junction on the PRR. The PRR did not use the LE&P, but the NYC used it for freight service only between Cleveland and Youngstown. East of Brady Lake Junction, the NYC exercised trackage rights on the PRR and B&O to reach Youngstown.

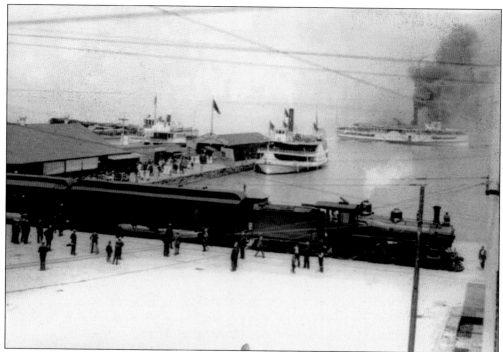

Commercial passenger service on Lake Erie dates to the early 19th century. The first steam-powered boat was the *Walk-In-The-Water*, built in 1818. In 1869, the Detroit & Cleveland Steam Navigation Company began scheduled overnight service between the two cities. The Cleveland & Buffalo Transit Company was organized in 1885 to provided service between its namesake cities. The C&B ultimately also operated side-wheelers to Toledo, Cedar Point, and Put-in-Bay. Both photographs on this page show an NYC train at the Cleveland Lake Erie docks in about 1900. The D&C and C&B began using a new dock in 1915 that was located at the foot of East Ninth Street. This facility was served by a streetcar line. The C&B ceased operations in 1939 after going bankrupt. The D&C continued in operation until 1951. Both companies lost business as the automobile grew in popularity. (Both, Cleveland State University Library Special Collections.)

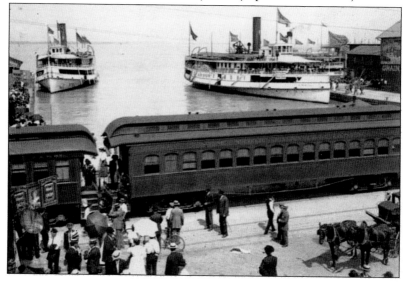

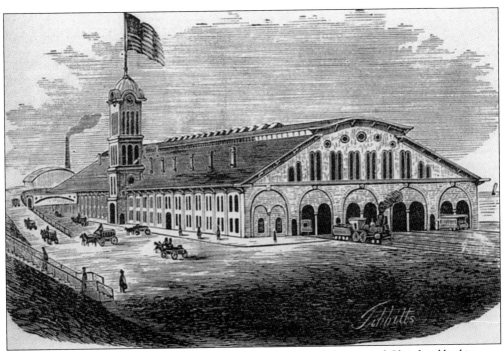

Until the construction of a Union Depot in 1853, each railroad that served Cleveland had its own passenger station. Cleveland's first Union Depot was destroyed by fire in 1864, and a second Union Depot was built at a cost of $475,000 near the site of the first station. Dedicated on November 10, 1866, the second Union Depot measured 603 by 108 feet and was, at the time, the largest building in the country under a single roof. The station was constructed of Berea sandstone and was among the first buildings to use structural iron. Its signature feature was a 96-foot clock tower on its southern facade. The image above of the second Union Depot was made from a wood engraving. (Both, Cleveland State University Library Special Collections.)

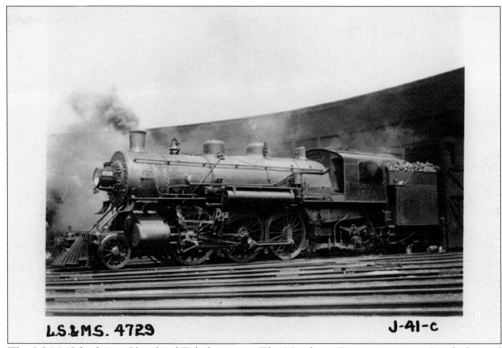

L.S.&M.S. 4729 J-41-c

The LS&MS had two Cleveland-Toledo routes. The Northern Division ran via Sandusky and Elyria. The Southern Division used the Big Four to Grafton; there, LS&MS trains gained their own tracks, operating via Oberlin and Norwalk before joining the Northern Division at Milbury. In 1866, a line was built from Elyria to Oberlin. The route between Oberlin and Grafton was removed, and use of the Big Four ceased. (Cleveland State University Library Special Collections.)

Wood was commonly used in the construction of railcars in the late 19th and early 20th century because lumber was plentiful and there was an abundance of workers with woodworking skills. Though metal cars might last longer and be fireproof, cars built with wood were less expensive. By the 1930s, railcars were made primarily of metal with wood sheathing, a practice that had ended by the 1950s. (Cleveland State University Library Special Collections.)

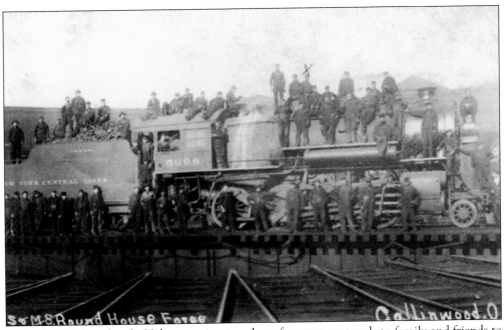

In the late 19th and early 20th centuries, travelers often sent postcards to family and friends to show where they had been or provide examples of what could be seen in their own communities. Railroad scenes were popular subjects for postcards, particularly during the first two decades of the 20th century when railroad travel was at its peak. Railroad postcards featured everything from stations to landmarks to railroad workers. It was common around the turn of the 20th century to pose shop workers on a locomotive, as seen in the image above on the LS&MS at Collinwood Yard in Cleveland. Sometimes, the image would simply be of one or more locomotives, as demonstrated in the image below of two LS&MS locomotives that were posed tender to tender at Collinwood Yard. (Both, Cleveland State University Library Special Collections.)

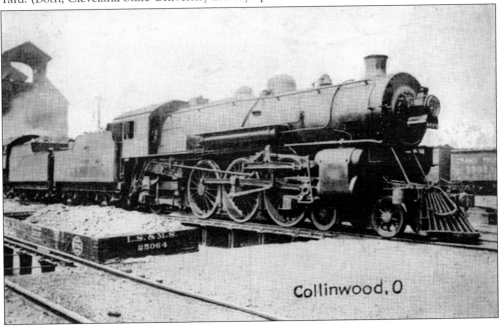

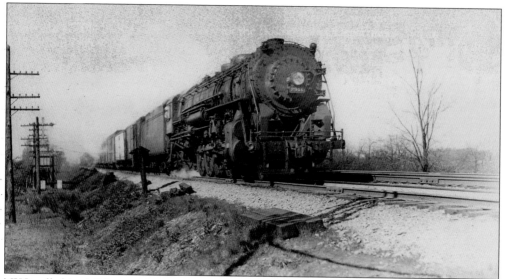

NYC called its 4-8-2 steam locomotives Mohawks, whereas other railroads used the Mountain-type designation. NYC used the Mohawk name because it emphasized that it was a railroad route that ran at water level. The NYC acquired its first Mohawk in 1916 for use on fast freight trains; it eventually owned 600 of them. L3-class No. 2956 is shown pulling a freight in Cleveland on May 1, 1938. (Cleveland State University Library Special Collections.)

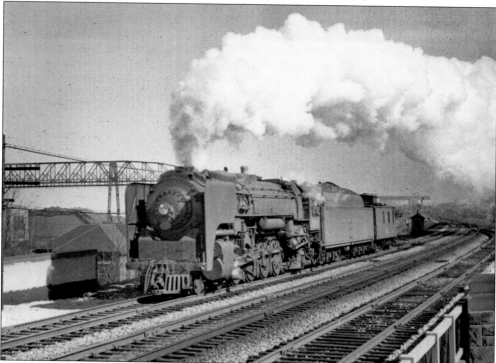

The L3a- and L4a-class NYC Mohawks were built without smoke deflectors and later had them added. L3-class No. 3021 is shown headed westbound with a caboose up west Park Hill at Bulkey Boulevard on March 3, 1946. An L3a-class locomotive was designed to haul freight or passenger trains. The NYC had 65 locomotives in this class, all built in 1940 by Alco.

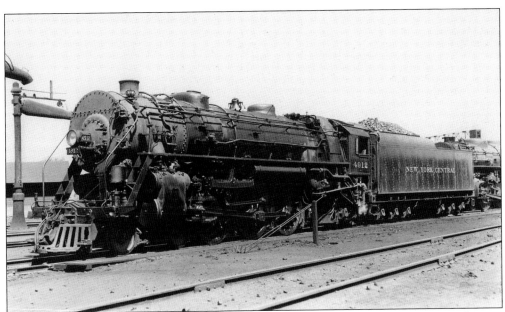

The 4-6-2 Pacific-type locomotive was the most pervasive locomotive used in the United States and Canada during the first half of the 20th century. The first Pacific was built in 1902, and by 1930, about 6,800 of these locomotives had been built for North American service. The NYC had more than 1,000 Pacifics in 26 classes. In the photograph above, No. 4912 reposes at a service facility on May 1, 1938, in Cleveland. This locomotive was one of 35 K5-class Pacifics on the NYC roster. These were the largest Pacifics on the roster and were built for express passenger service. They were built by Alco in 1924 and were the last Pacifics produced for the NYC. In the photograph below, No. 4510 is shown in Cleveland in an undated photograph. (Both, Cleveland State University Library Special Collections.)

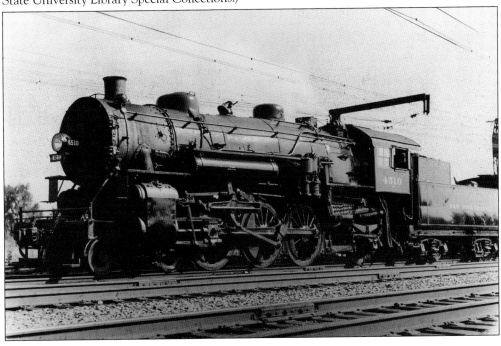

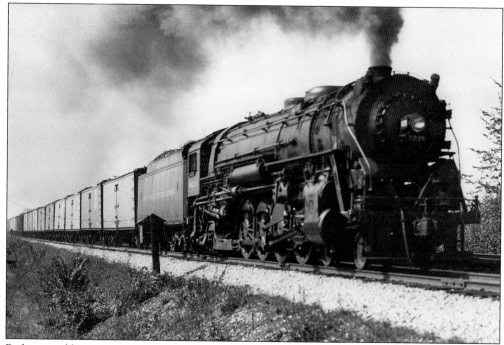

Refrigerated boxcars, often called reefers, enabled railroads to carry meat and produce over long distances. Reefers commonly operated in dedicated trains that had expedited schedules that, in some instances, gave them priority over passenger trains. Many reefers used ice to provide refrigeration, and these trains had to stop at designated points to receive new ice. A NYC reefer train is shown in Cleveland in an undated photograph. (Cleveland State University Library Special Collections.)

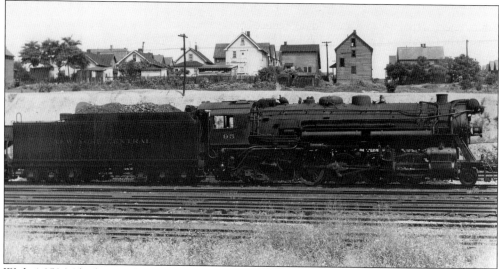

With 1,350 Mikado-type locomotives in the system, the NYC was the nation's largest operator of the 2-8-2 engine. First built in the early 1900s, most of these locomotives had entered service by the 1930s. No. 95, pictured here in an undated photograph at Cleveland, was an H10a-class locomotive. The NYC had 57 of these, all built between 1922 and 1923 by Alco. (Cleveland State University Library Special Collections.)

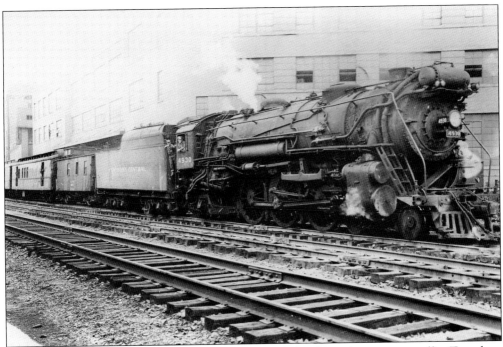

By 1900, the NYC's Lakefront Line was clogged with freight and passenger traffic. To reduce congestion, the Cleveland Short Line Railway constructed (between 1910 and 1912) a double-track line between Collinwood and Rockport that bypassed downtown. Another congestion-reducing step was building a passenger terminal on Public Square. Backed by the Van Sweringen brothers, the proposed CUT received support from A.H. Smith, a regional director of the United States Railroad Administration (USRA), which controlled the nation's railroads during World War I. O.P. Van Sweringen wanted to extend the tracks directly north from CUT to the lakefront, but Smith rejected that because it would not reduce congestion. He favored building a new route that crossed the Cuyahoga River on a high-level bridge. These images both show NYC K–class Pacifics built in 1924 by Alco. (Both, Cleveland State University Library Special Collections.)

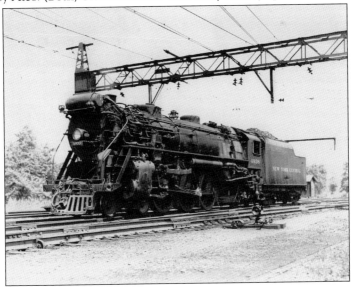

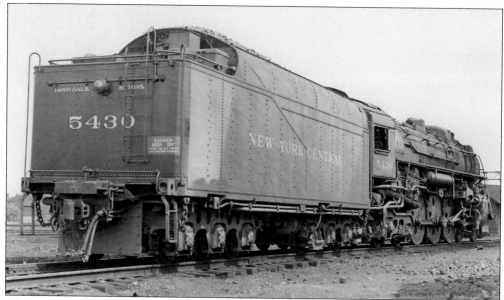

Alco built 265 of the NYC's Hudsons, while Lima built 10. The first was delivered on February 14, 1927, and the last arrived in 1938. NYC subsidiary Michigan Central Railroad was assigned 30 of the locomotives, while 30 went to the Big Four, 20 to the Boston & Albany Railroad, and 195 to the NYC proper. No. 5430 and its tender were photographed in Cleveland on May 21, 1939. (Cleveland State University Library Special Collections.)

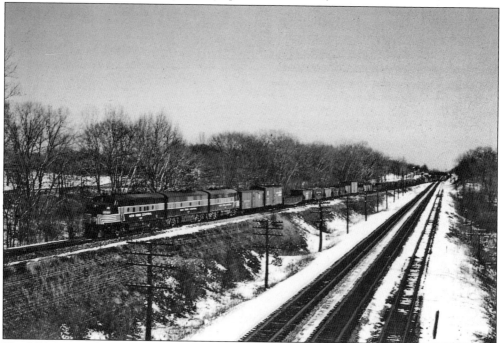

The LE&P never hosted passenger trains and was used only by the NYC even though the PRR had an ownership stake in it. Most of the LE&P was abandoned by PC in the early 1970s. A small portion remained in place near Twin Lakes to serve a sand company. Here, a westbound NYC train has just entered the LE&P at Brady Lake in March 1957. (Photograph by Bob Redmond.)

The early 1950s saw a mixture of steam and diesel power on NYC trains in Cleveland. There were still many steam locomotives operating on the former Big Four, but their numbers were steadily dwindling. A westbound freight pulled by a 4-8-2 Mohawk locomotive is pictured here at West Twenty-fifth Street in Cleveland, passing the Federal Coal yard. (Cleveland State University Library Special Collections.)

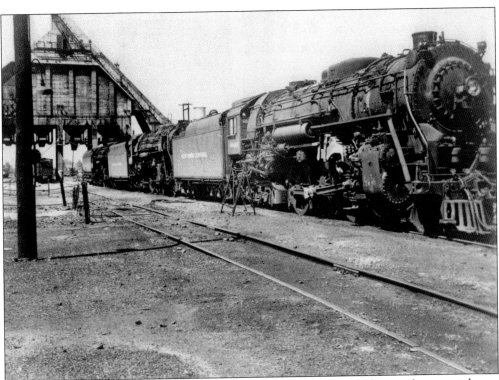

The NYC was not among the earliest railroads to forsake steam for diesel power, but once it began to dieselize, it moved quickly. It replaced steam locomotives with diesels from east to west, and the system east of Buffalo, New York, was converted by fall 1953. In this image, three Hudson-type locomotives sit silently on the dead track at Collinwood Yard on June 19, 1956, soon to meet the scrapper's torch. (Cleveland State University Library Special Collections.)

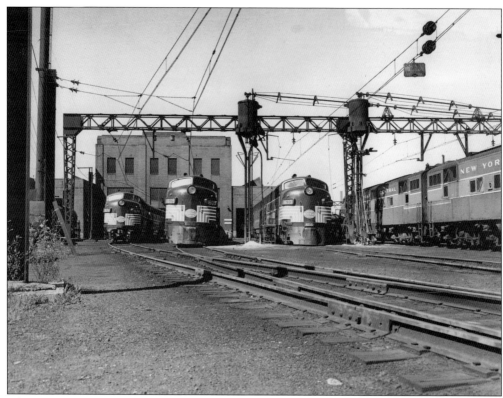

Above, a trio of F-series diesel-electric locomotives built by EMD sits at the service facility in Collinwood Yard on July 27, 1950. These locomotives were primarily used in freight service, and each was rated at 1,500 horsepower. The locomotives are, from left to right, No. 1633 (an F3A), No. 1609 (an F3A) and No. 1674 (an F7A). Altogether, the NYC had 341 F units, the first of which it acquired in 1944 when it ordered eight FT-model locomotives. The NYC spent two years studying the performance of the FTs before it ordered any more freight diesels. Below, a crewmember watches F7A No. 1836 and a B unit maneuver at the Collinwood shops. (Both, Cleveland State University Library Special Collections.)

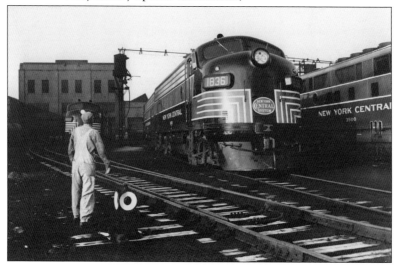

The NYC's EMD E-series diesels were used in passenger service throughout the system. The first of these that the NYC ordered were 50 E7 locomotives that it acquired between 1945 and 1949. In the undated image at right is E7A No. 4002 with the engineer waving for the photographer. NYC's E7 fleet included 36 cab and 14 booster locomotives. This model of locomotive generated 2,000 horsepower. In the undated photograph below, E8A Nos. 4044 and 4043 are seen at Cleveland. NYC ordered 60 of these locomotives between 1951 and 1953. Although intended for passenger service, some E units were assigned to Super Van intermodal trains. Some NYC E units continued to pull passenger trains for PC and, later, for Amtrak. Nos. 4043 and 4044, both built in September 1951, became Amtrak Nos. 260 and 261 respectively. (Both, Cleveland State University Library Special Collections.)

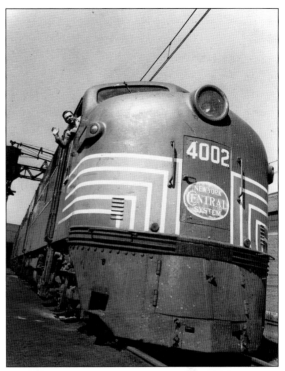

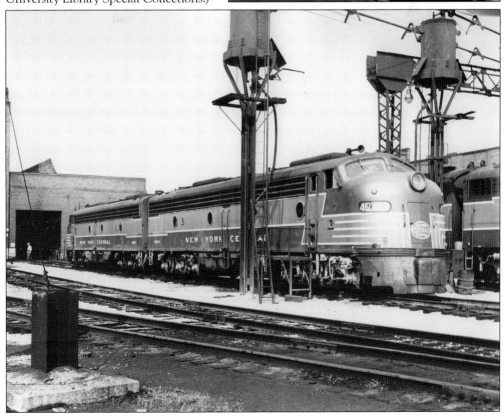

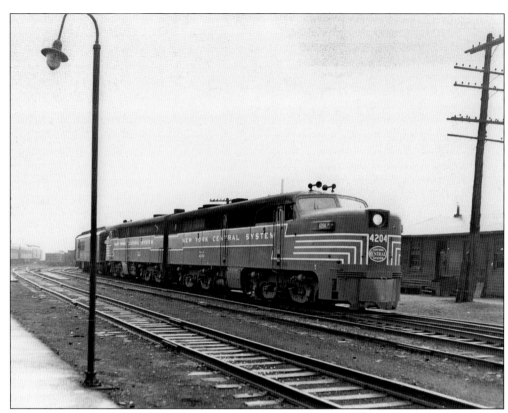

The NYC bought diesel locomotives from six manufacturers, including Alco, which had built most of NYC's steam locomotives. NYC's all-time diesel roster, including subsidiaries and affiliated railroads, listed 2,751 locomotives. The NYC usually assigned diesels to designated pools, basing them at or near a home repair terminal. With 770 units, the NYC had one of America's largest rosters of Alco diesel locomotives. Ultimately, the NYC had more EMD and GE locomotives than Alco products. Among the Alco locomotives that the NYC used were 30 PA/PB passenger locomotives. Shown above are PA-1 No. 4204 and another unidentified locomotive pulling a passenger train. The NYC often assigned these passenger diesels to Cleveland-Pittsburgh trains. It also ordered 35 Fairbanks-Morse C-liner cab units for passenger service, including No. 4505, shown with a mate in Cleveland in an undated photograph below. (Both, Cleveland State University Library Special Collections.)

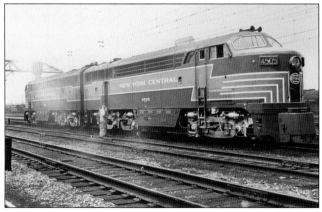

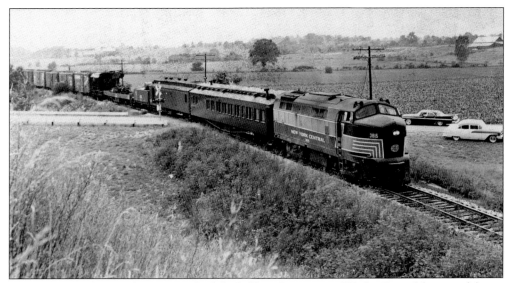

The NYC owned just 99 locomotives built by Baldwin Locomotive Works. One of those models was the RF16, which had the nicknames "shark" or "shark nose." Most of the NYC's RF16 locomotives were assigned to former Big Four routes in Ohio and Indiana. Originally numbered in the 3804-to-3821 series, the sharks were later renumbered 1204 to 1221. This NYC freight train includes work-train equipment and a crane. (Cleveland State University Library Special Collections.)

Most people encountered railroads in one or two situations. They rode trains as passengers for business or pleasure, or they found themselves waiting for trains at grade crossings. This 1956 image shows a NYC local freight train crossing Lakewood Heights Boulevard. At the head of the train is Alco S-1 switcher No. 835, which originally wore No. 716 and was eventually assigned No. 9319. (Cleveland State University Library Special Collections.)

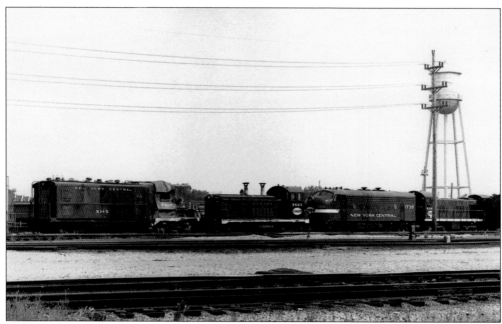

A collection of NYC motive power spends its final days on the dead line at Collinwood Yard on September 9, 1967, including a locomotive that was involved in a derailment. The XH5 is a steam-heater car that was used on passenger trains to provide steam for heating and cooling. Also shown are No. 8693, a model NW2 switcher; and No. 1736, an F7A road diesel. (Photograph by Robert Farkas.)

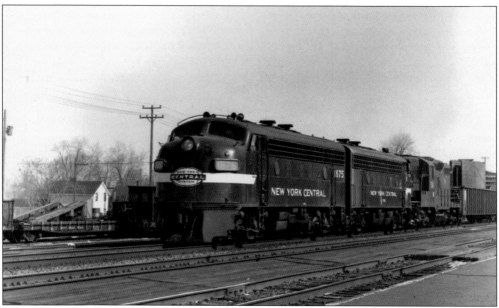

The NYC had 238 F7A locomotives that were built by EMD between 1949 and 1953 and rated at 1,500 horsepower. Although promoted by EMD as a freight-service locomotive, F units were used by some railroads in passenger service. In freight service, they were often used on trains that did not require much switching. Nos. 1675 and 1702 are shown leading a freight at Painesville. (Photograph by Robert Farkas.)

Freight traffic could be seasonal, and a railroad might find itself short of enough locomotive power to handle traffic surges. In such instances, a railroad might lease locomotives from another railroad for the short term. Shown at Collinwood Yard is an A-B-A set of F7 locomotives that the NYC leased from the Great Northern Railway. Behind the locomotives is Collinwood's massive coal dock. (Photograph by Robert Farkas.)

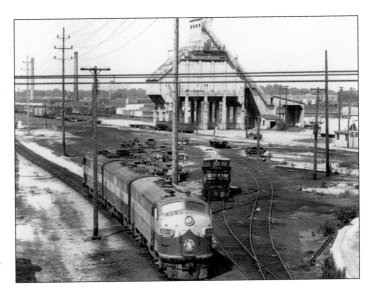

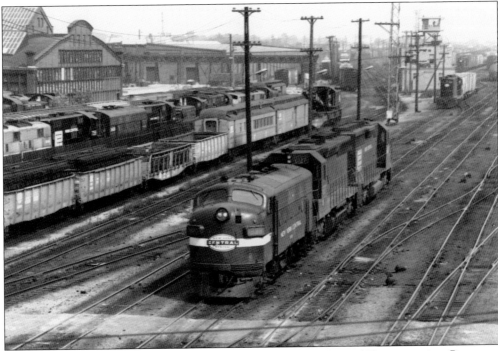

The NYC and PRR merged on February 1, 1968, to form Penn Central Transportation Company. For a while, it was common to see locomotives still bearing NYC or PRR markings mixed in with locomotives in PC's livery of an interlocked P and C. Shown in the foreground of an image made at Collinwood is a lash-up of locomotives with markings from all three railroads. (Photograph by Robert Farkas.)

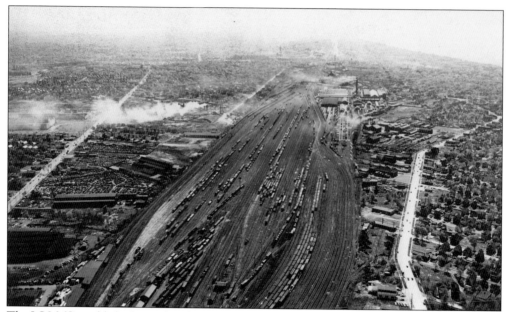

The LS&MS established a yard and repair shops in 1874 in the village of Collinwood, northeast of Cleveland. At that time, the facility had 500 employees who handled 72 freight trains a day. The facility was expanded in 1903 and again in 1929. By now, Collinwood had become a major classification yard for the NYC that employed more than 3,000 and featured 120 miles of track. The village of Collinwood, which had grown to a population of 3,200 by the 1890s, was annexed by the city of Cleveland in 1910. The yard is located between Interstate 90 and Saranac Road. The photograph above, taken on May 4, 1949, provides a sense of how large the yard is. In the photograph below, diesel switchers and one steam locomotive shuffle freight cars and assemble trains. (Both, Cleveland State University Library Special Collections.)

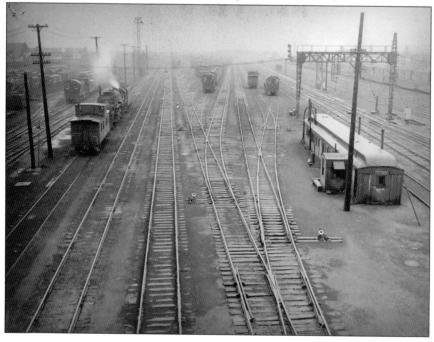

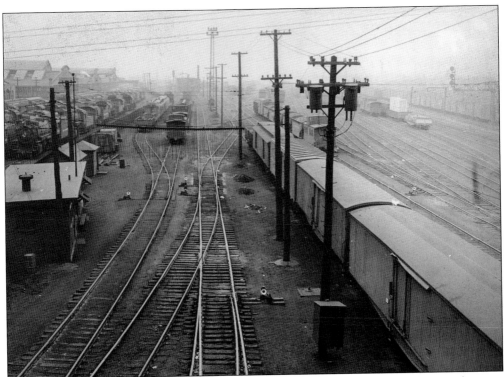

The two images of Collinwood Yard on this page were taken from approximately the same location and show how much a railroad can change in two years. Each photograph was taken on a bridge carrying East 152nd Street over the yard. The image above dates to 1953. Note that there are several steam locomotives clustered near the shop buildings. It is not clear from the information with the photograph if these locomotives were still active or were waiting to be scrapped. The NYC was well along with retiring steam locomotive power used east of Cleveland at this time. The photograph below was taken in March 1955. Steam power had not yet vanished from the NYC, but it had less than two years before it ended. By now, most motive power was diesel locomotives. (Both, Cleveland State University Library Special Collections.)

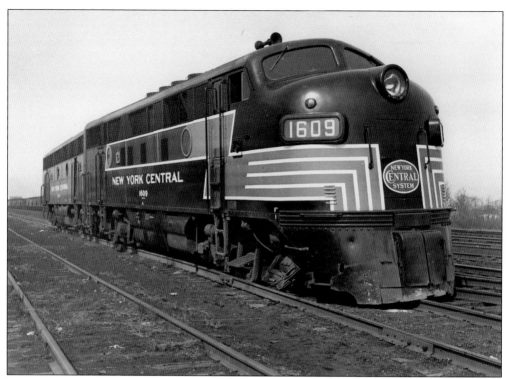

Railroads go to great lengths to avoid accidents that cause injury to employees and the public. In the photograph above, No. 1609 has derailed at Collinwood Yard on May 12, 1950. It took some work to clean this up, but it is not likely that a wrecker will need to be called to the scene. No. 1603 is an FTA model built by EMD. In the photograph below, it took a crane to get this NYC caboose back onto the tracks. This accident occurred along Lorain Street on July 4, 1963. The photograph did not include any information about the cause of this accident, but it does not appear that anyone on the street or sidewalk was injured. The sight of a caboose resting on the sidewalk next to a main street must have attracted a lot of curiosity seekers. (Both, Cleveland State University Library Special Collections.)

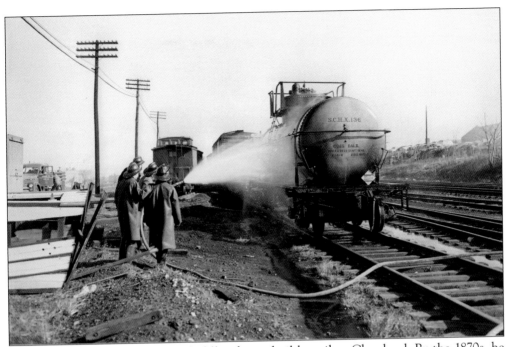

Young businessman John D. Rockefeller shipped oil by rail to Cleveland. By the 1870s, he controlled most of the city's refineries and had established the Standard Oil Company. Refiners needed sulfuric acid, which prompted the growth of a sizable chemical industry in Cleveland. The city's chemical factories were soon producing a range of industrial chemicals. The availability of petroleum products in Cleveland also resulted in the development of a paint-and-varnish industry in the 1870s. Henry Sherwin and Edward Williams formed the Sherwin-Williams Company, while Francis H. Glidden in 1875 formed a company that sold varnishes and enamels. It is not clear why firefighters are spraying the tank car shown in these two images. The incident occurred on the NYC on November 9, 1952, near East Twenty-fifth Street and Lakeshore Boulevard. (Both, Cleveland State University Library Special Collections.)

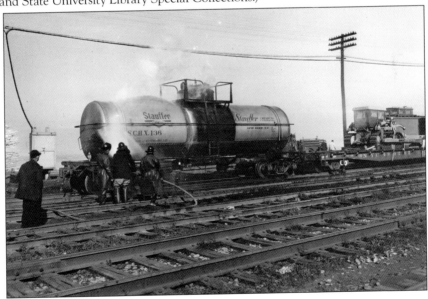

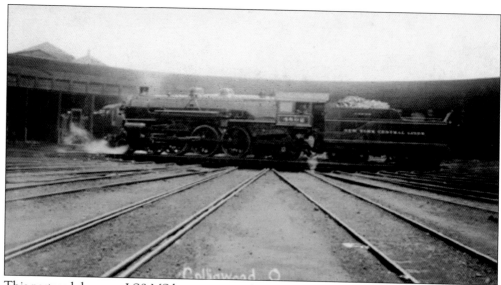

This postcard shows an LS&MS locomotive at the Collinwood roundhouse in about 1908. Note that the tender carries the name "New York Central Lines," a designation that the NYC used on equipment assigned to railroads that it leased. The brick roundhouse was built when Collinwood Yard was established in 1874. It has since been demolished, but locomotive-service facilities still exist at Collinwood, which is now owned by CSX Transportation. (Cleveland State University Library Special Collections.)

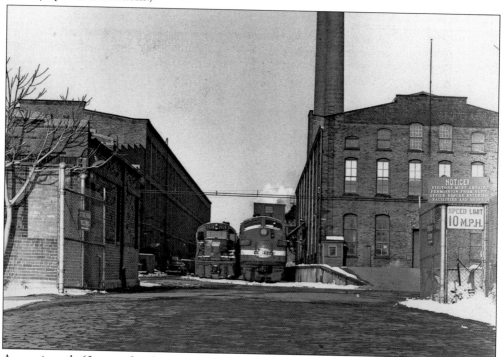

Approximately 60 years after the image above was made, the motive power at Collinwood changed dramatically. Steam locomotives were gone, but some shops that were built to care for them still stood. PC No. 2628 (left) is a U25B originally built in 1962 for the PRR for heavy freight service. NYC No. 4023 is an E7A locomotive built for passenger service. (Photograph by Robert Farkas.)

QD Tower, later known as Quaker Tower, controlled the interlocking plant at Collinwood where tracks of the NYC's Short Line and Lakefront Line and the CUT came together at the west end of the yard. The tower is shown under construction in an undated photograph. It continued in service through the 1990s, but control of the interlocking was later passed on to a dispatcher, and the tower was closed. (Cleveland State University Library Special Collections.)

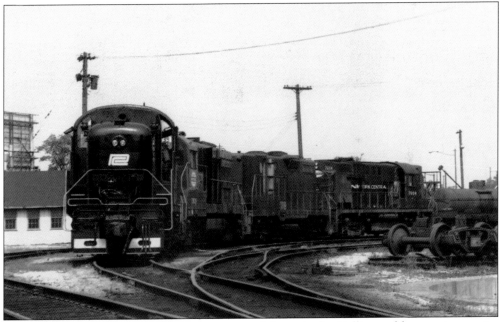

A wide variety of diesel locomotive power passed through the Collinwood locomotive service facilities during the late 1960s, particularly after the PC merger. Shown in the fall of 1968 are an Alco locomotive that was painted into the Spartan PC livery and some NYC power that still has its original markings. First- and second-generation diesels were common at Collinwood in this era. (Photograph by Robert Farkas.)

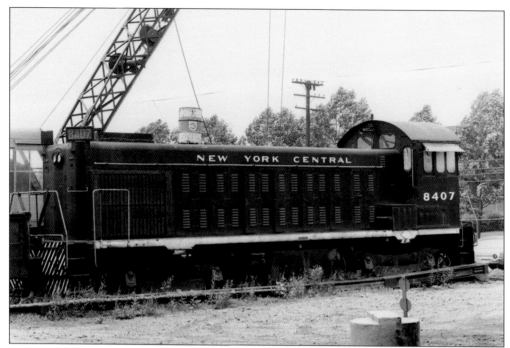

The LS-1000 was introduced in 1949 by Lima Locomotive Works. Only 38 units were built, including six for the NYC. No. 8407 originally was lettered for a NYC subsidiary, the Chicago River & Indiana Railroad, but by the time this photograph was made, it had been reassigned to the NYC roster. It is shown working in a Cleveland scrap yard on June 29, 1968. (Photograph by Robert Farkas.)

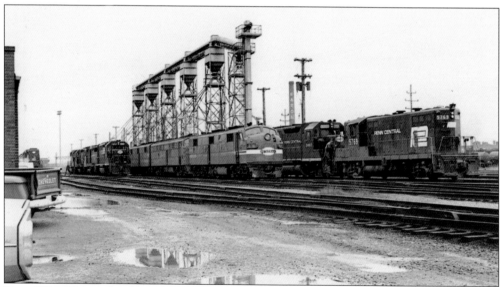

Here, PC is 11 months old, and the Collinwood locomotive-service facility remains the place to photograph a variety of motive power. In this image made on November 16, 1968, passenger and freight power alike await their next assignments. PC aggressively sought to end the remaining passenger service on the former NYC and PRR, so the need for E7A No. 4019 was diminishing. (Photograph by Robert Farkas.)

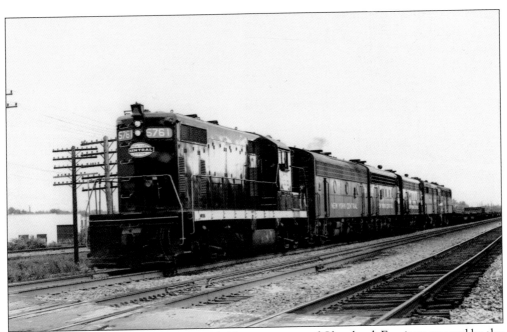

GP7 No. 5761 leads a parade of EMD and Alco power east of Cleveland. F units were used by the NYC and PC to pull freight trains in the Cleveland area. One F7A locomotive, No. 1648, was painted in Consolidated Railroad Corporation colors and was still working in the mid-1970s. No. 5751 also joined the Conrail roster when that railroad was created on April 1, 1976. (Photograph by Robert Farkas)

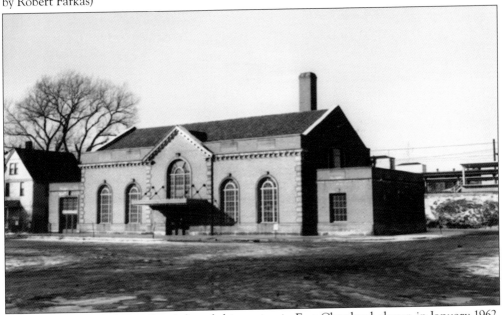

The NYC and Nickel Plate Road shared this station in East Cleveland, shown in January 1962, which was located along the electrified portion of the CUT tracks. The NYC had a 91.5-percent ownership share, while the NKP owned 8.5 percent. The NYC was responsible for station operations and maintenance, but each railroad owned and maintained its own platforms, canopies, and elevators. (Photograph by Herbert Harwood.)

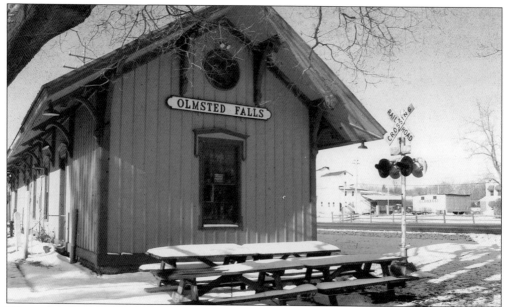

When the LS&MS built this station in Olmsted Falls in 1876, it was way out in the country. NYC passenger trains still stopped here twice a day through late 1949, but by late 1952, no trains were scheduled to stop in Olmsted Falls. Located 15 miles west of CUT, the Olmsted Falls depot is today owned by the Cuyahoga Valley & West Shore Model Railroad Club. (Photograph by Craig Sanders.)

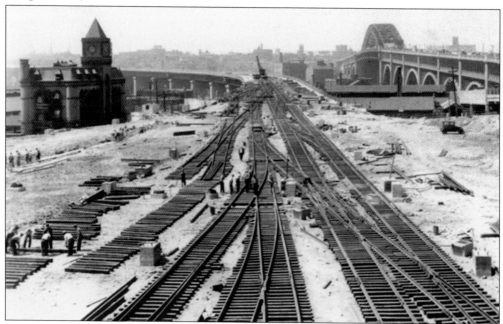

The Cleveland Group Plan designed by Chicago architect Daniel Burnham called for a Union station along the lakefront, but Cleveland businessmen and brothers O.J. and M.P. Van Sweringen led a campaign that, in January 1919, culminated in the passage of an ordinance to locate the station on Public Square. The west approach tracks are shown here under construction, and the B&O station is visible to the left. (Cleveland State University Library Special Collections.)

Railroads used timetable covers as a marketing tool. The image at left shows a timetable issued on April 2, 1933, by the Big Four, which at the time was still an autonomous entity even if it was controlled by the NYC. The somewhat ornate design clearly reflects the NYC control of the Big Four. The slogan, "The Water Level Route—You Can Sleep," was used by the NYC for decades. The image below shows a regional timetable issued by the NYC on November 5, 1967. By now, NYC timetable covers were more functional, showing only the scope of service, and NYC passenger service in Cleveland had shrunk to nine trains a day. These trains continued to operate during the PC era, and all were discontinued on May 1, 1971, with the coming of Amtrak. (Both, Craig Sanders collection.)

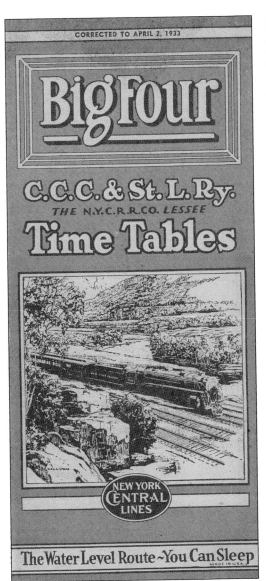

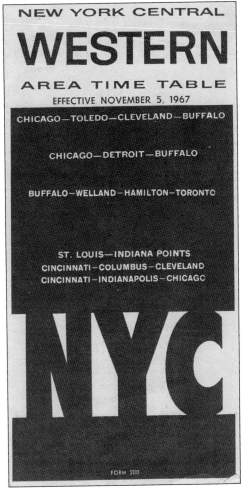

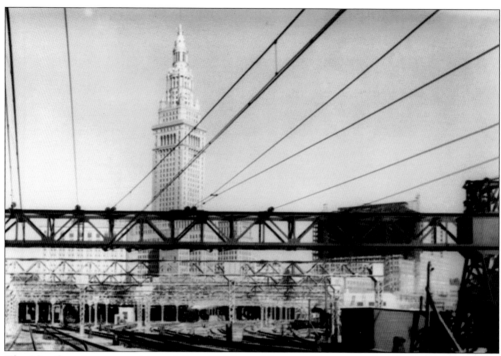

The Van Sweringens envisioned that CUT would serve all steam railroads, most interurban railways, and their planned regional rapid-transit system. But interurban railways were declining and never used CUT. The PRR announced in December 1919 that it would not use CUT. Only the Shaker Heights Rapid of the proposed rapid-transit network was ever built. Shown are the tracks at the east end of CUT just before its opening. (Cleveland State University Library Special Collections.)

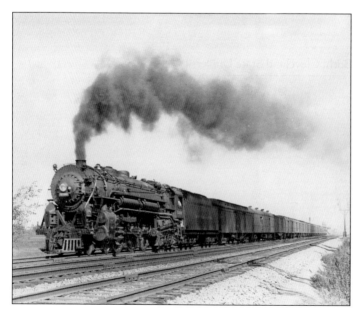

The Hudson steam locomotives of the NYC were numbered consecutively, starting with 5200 and ending with 5474. To do this, the NYC renumbered some Hudson locomotives on its B&A subsidiary that had arrived with road numbers 600–619. No. 5266 is a J1-class Hudson built by Alco in 1927. It is shown pulling No. 624, a Cleveland-to-Baltimore train that operated over the Erie and B&O Railroads. (Cleveland State University Library Special Collections.)

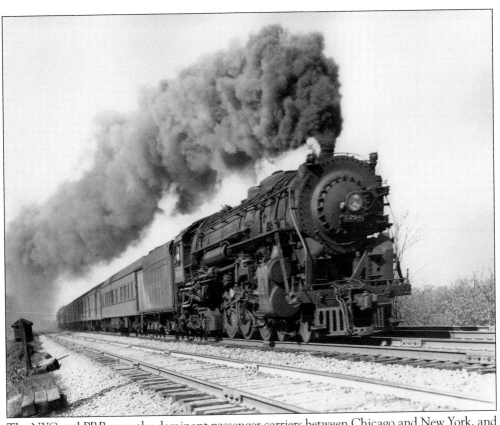

The NYC and PRR were the dominant passenger carriers between Chicago and New York, and no other railroad could match the number of trains that each offered. The NYC and PRR had another edge in that they went into Manhattan. The New York trains of other carriers terminated in New Jersey, and passengers had to take a boat or bus to Manhattan. The PRR's Chicago mainline passed through Canton, 60 miles south of Cleveland. The NYC offered the most destinations from Cleveland as well. From Cleveland, the NYC had direct service to Florida via an interchange at Cincinnati with the Southern Railway and the Louisville & Nashville Railroad. The photograph above shows eastbound No. 78 in Cleveland on May 1, 1938. The photograph below was also made in Cleveland but is undated. (Both, Cleveland State University Library Special Collections.)

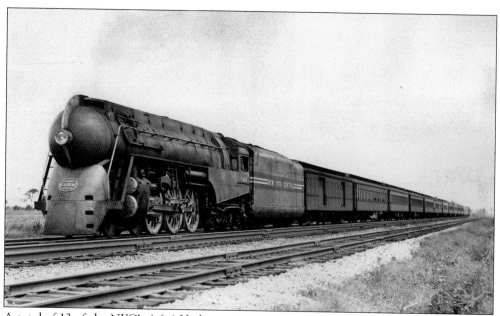

A total of 13 of the NYC's 4-6-4 Hudson-type steam locomotives were streamlined. No. 5344 was the first to be streamlined, receiving a "bathtub-like" shrouding in 1934 that was designed by the Case School of Science in Cleveland. In 1938, Alco built 10 J-3–class Hudsons—Nos. 5445 through 5454—with a streamlined look created by industrial designer Henry Dreyfuss. The streamlined design was intended to complement the motif that Dreyfuss gave to new passenger cars ordered for the *Twentieth Century Limited*. In the photograph above, No. 5445 leads No. 49, the *Iroquois*, through Cleveland on August 10, 1939. This New York–to–Chicago train was renamed the *Chicagoan* on April 27, 1957, and continued in service until December 3, 1967. In the bottom photograph, No. 5449 leads an unidentified train in Cleveland in 1939. (Both, Cleveland State University Library Special Collections.)

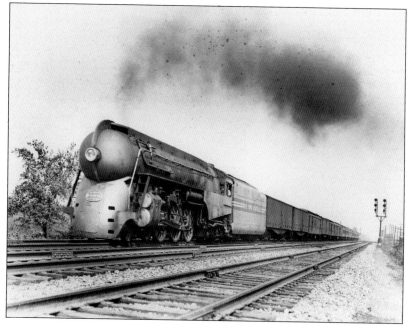

No. 5344 was the NYC's first steam locomotive to be streamlined. After receiving a "bathtub-like" shroud in 1934, it pulled the *Twentieth Century Limited* between Chicago and Toledo. It received new shrouding in July 1939 to match the look of newly built, streamlined J3s. The shrouding was removed following a grade-crossing accident with a sand truck. No. 5344 also served as the prototype for a Lionel O-gauge model. (Cleveland State University Library Special Collections.)

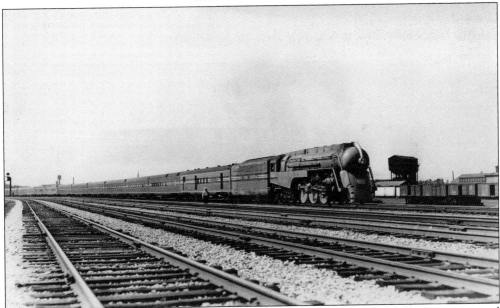

In June 1938, the NYC debuted a new look for its flagship *Twentieth Century Limited*. The cars received a livery of two-tone gray with blue and silver stripes. This train, photographed in Cleveland on May 8, 1940, reflects that new look, but the *Century* came through during nighttime hours. It is either a very late *Century*, the *Commodore Vanderbilt*, or the *Southwestern Limited*, which also received cars with the new livery. (Cleveland State University Library Special Collections.)

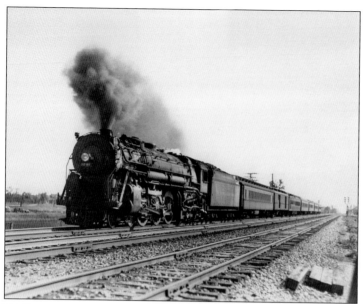

The NYC developed the Hudson-type steam locomotive in 1926 because it needed a more powerful engine for passenger service. The existing Pacific-type locomotives could only handle 12 cars, and some mainline trains had to operate in separate sections. The NYC and its subsidiaries eventually operated 275 Hudsons. No. 5248 has a seven-car train in tow in the late 1930s in Cleveland. (Cleveland State University Library Special Collections.)

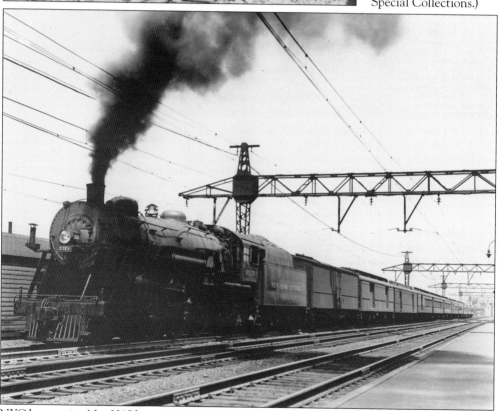

NYC locomotive No. 3315 has an 11-car train in hand under the CUT wires on July 24, 1934. The train's makeup, with its heavyweight cars, is typical of the era. Supplementing the three head-end cars is a combine. During the 1930s, many railroads stepped up their efforts to air-condition their passenger cars, and they prominently promoted this in timetables and advertisements. (Cleveland State University Library Special Collections.)

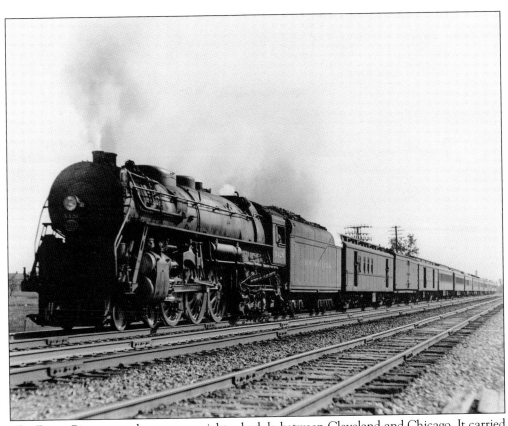

The *Forest City* operated on an overnight schedule between Cleveland and Chicago. It carried numerous sleeping cars and coaches. During the World War II era, it operated in two sections eastbound, with the *Advance Forest City* continuing to New York. The two sections were scheduled to depart Chicago 10 minutes apart, but they arrived in Cleveland 50 minutes apart. The eastbound *Forest City* is shown at Cleveland on May 1, 1938. (Cleveland State University Library Special Collections.)

The Niagara-type locomotive was a 4-8-4 built by Alco. On other railroads, this type of locomotive was known as a Northern, but NYC named its fleet after Niagara Falls. NYC ordered 27 of these locomotives, and they were delivered between 1945 and 1946. Following World War II, they were used primarily in passenger service. No. 6021 is shown pulling the *New York Special* at Berea in an undated photograph. (Cleveland State University Library Special Collections.)

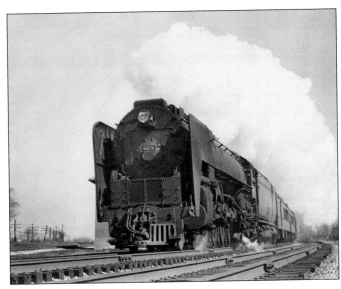

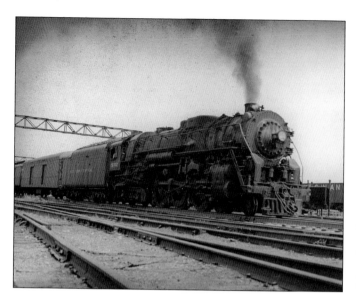

Hudson-type locomotive No. 5312 pulls an unidentified passenger train in June 1955 at Linndale during the twilight era for steam power on the NYC. The last steam operation on the NYC occurred on May 2, 1957, when class H-7a No. 1977 (a 2-8-2), formerly No. 6177, worked for the last time at Riverside Yard in Cincinnati. By mid-August 1953, NYC steam locomotives no longer operated east of Cleveland. (Cleveland State University Library Special Collections.)

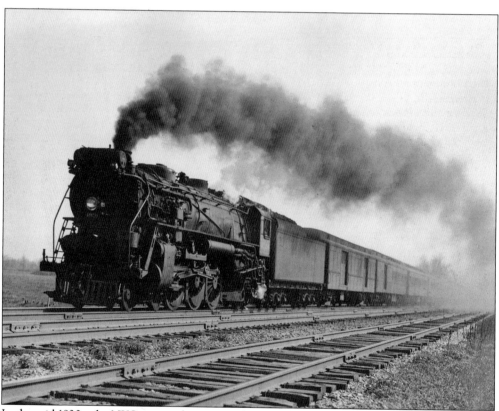

In the mid-1930s, the NYC operated nine round-trips between Cleveland and Cincinnati via the former Big Four. Many of those trains featured the names of the endpoint cities in their names, including No. 119, the *Cincinnati Special*, which is shown in Cleveland on May 6, 1939, behind Big Four No. 4926, a 4-6-2 Pacific-type locomotive. No. 119 made the trip to Cincinnati in six hours flat. (Cleveland State University Library Special Collections.)

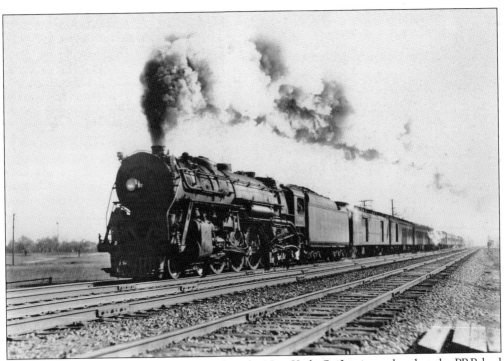

The NYC and PRR also fiercely competed in the New York–St. Louis market, but the PRR had the faster, more direct route. In Cleveland, the NYC had the only direct service to St. Louis. Cleveland–St. Louis service crested in 1930 at seven round-trips. The premier train was the *Southwestern Limited*, which the Big Four had begun on October 6, 1889. Other notable St. Louis route trains included the *Knickerbocker* and the *Missourian*. NYC sought to end all passenger service west of Indianapolis, but state regulatory commissions in Indiana and Illinois only allowed the discontinuance of two of the four pairs of trains that operated to St. Louis, effective August 17, 1958. The *Southwestern Limited* is shown above westbound in Cleveland on May 1, 1938, while an unidentified westbound train is shown below on the ex–Big Four at Wellington in 1954. (Both, Cleveland State University Library Special Collections.)

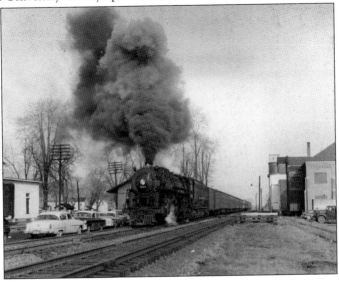

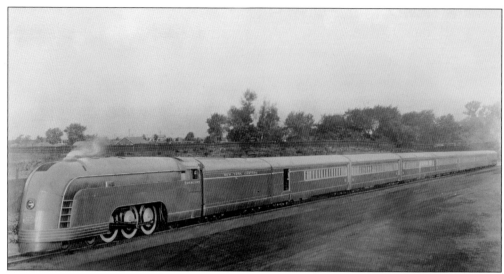

The *Mercury* was a streamlined passenger train that began Cleveland-Detroit service on July 15, 1936. The NYC could not afford new equipment, so it rebuilt Osgood-Bradley commuter coaches into luxury coaches, a lounge car, a diner, and an observation car, all designed by Henry Dreyfuss. The *Mercury* made the trip to Detroit in slightly less than three hours, with Toledo being the only intermediate stop. The equipment featured a striking design. Inside were curved leather divans and armchairs rather than the traditional two-by-two seating. The 4-6-2 Pacific locomotive was shrouded except for its driving wheels, which were illuminated at night. By its first anniversary, the *Mercury* had grown from seven to nine cars and had carried 112,000 passengers. The NYC subsequently launched a series of Midwest-corridor trains with the *Mercury* name, including one operating between Cleveland and Cincinnati. (Both, Cleveland State University Library Special Collections.)

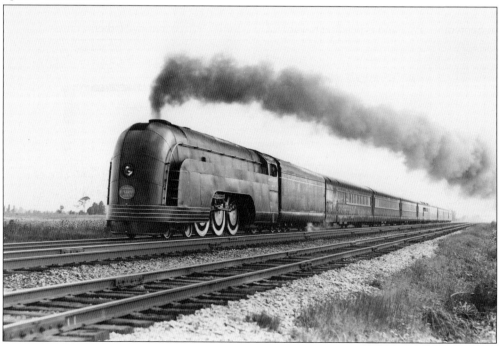

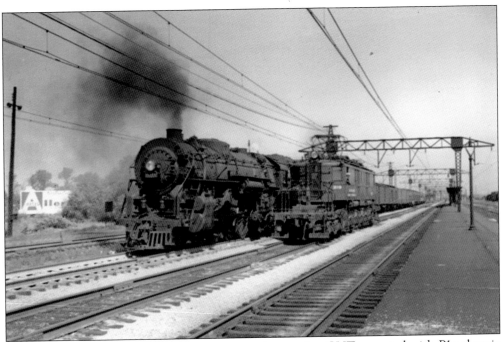

For more than two decades, NYC passenger trains serving CUT operated with P1a electric locomotives. CUT ordered 22 of the 3,000-volt locomotives from Alco-General Electric, and they were built between 1929 and 1930. NYC trains switched from steam to electric power at Collinwood Yard on the city's east side and at Linndale on the west side. NYC constructed a repair shop at Collinwood that was still called "the P1a" decades after the electrics had been removed from CUT service. In the photograph above, NYC No. 407, the westbound *Cleveland–St. Louis Special*, has exchanged its P1a in September 1953 for a steam locomotive at Linndale, which was located on the former Big Four. In the photograph below, P1a No. 206 has hooked onto an eastbound train in September 1952 and is heading toward CUT. (Both photographs by Herbert Harwood.)

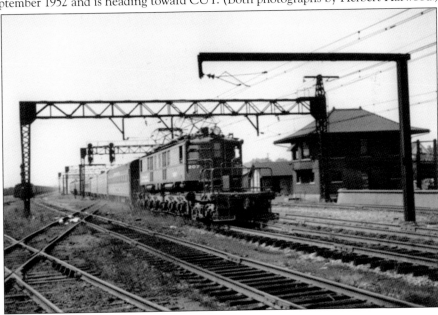

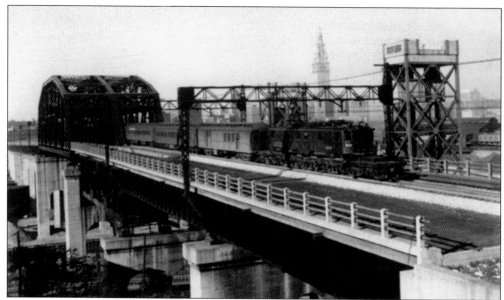

CUT built 17 route miles of electrified track to avoid smoke and soot coming from its underground station. CUT's P1a electric locomotives were 80 feet long and weighed 204 tons. By the early 1950s, most of the passenger trains using CUT used diesel-electric locomotives, and the need for electric locomotives diminished. CUT ceased using its P1a locomotives in 1953, and 21 of them were refurbished by the NYC for use in the electrified territory of New York City, where they operated as P2 locomotives. In the photograph above, an NYC train has departed CUT and is approaching West Twenty-fifth Street in 1944. This bridge over the Cuyahoga River was built as part of the CUT project. In the photograph below, a P1a pulls the *Empire State Express* through East Cleveland in 1954. (Above, photograph by Anthony Krisak; below, photograph by Herbert Harwood.)

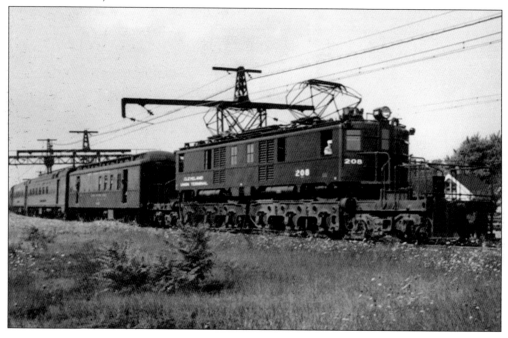

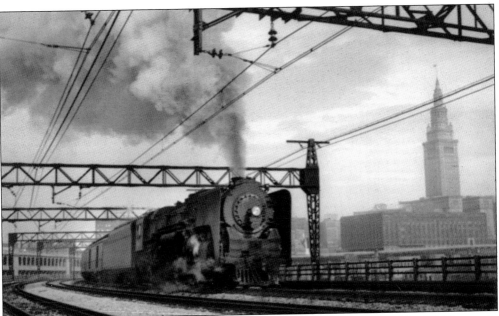

Steam locomotives briefly operated out of CUT in the 1950s. Here, NYC No. 3012 has train No. 433, the *Cleveland-Cincinnati Special*, charging over the CUT viaduct in January 1955. No. 433 carried a sleeper as a parlor car and a diner/lounge. It made the trip to the Queen City in six and a half hours. The last steam operations on the NYC occurred on the former Big Four routes. (Photograph by Herbert Harwood.)

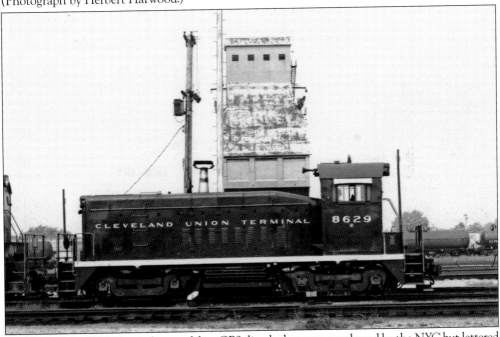

CUT had three SW900 switchers and four GP9 diesels that were purchased by the NYC but lettered for and assigned to duty at CUT. Switchers were needed to switch passenger cars, and mail and express cars from many of the trains that called at CUT. No. 8629 eventually passed to Conrail ownership before being sold to a New Jersey steel company. (Photograph by Robert Farkas.)

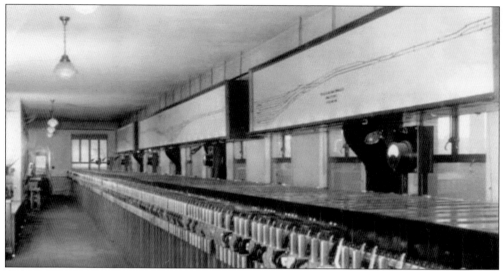

CT Tower controlled train movements over three and a half miles of CUT track between East Thirty-fourth and West Twenty-fifth Streets. Operators used levers to set the signals and switches. The CT interlocking machine had 576 levers and was the largest electromechanical interlocking machine in the country when CUT opened in 1929. The model board above the interlocking machine showed the locations of trains, and lights illuminated when trains passed certain control points. (Cleveland State University Library Special Collections.)

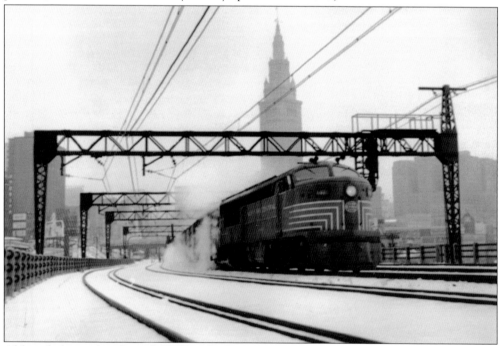

Although four railroads used CUT, only the passenger trains of the NYC and NKP used the CUT viaduct over the Cleveland Flats west of the station. NYC No. 407, the *Cleveland-St. Louis Special*, departs CUT in December 1954 shortly past noon en route to St. Louis. This train carried coaches and a parlor car out of Cleveland and picked up a dining car in Indianapolis. (Photograph by Herbert Harwood.)

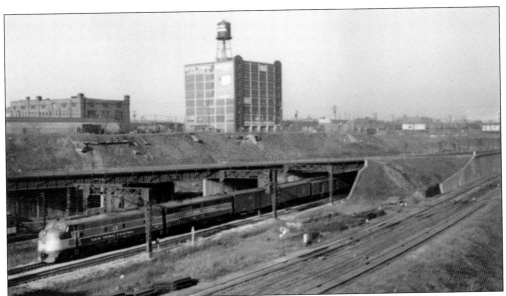

The *South Shore* operated between New York and Chicago. A late 1959 timetable showed that it was scheduled to arrive into Cleveland at 5:55 p.m. and operated as a local across Ohio. Shown at old Broadway Avenue in Cleveland in April 1960, No. 43 picked up coaches at Cleveland for Chicago but carried no sleepers west of Buffalo. It was discontinued on September 24, 1960. (Photograph by Herbert Harwood.)

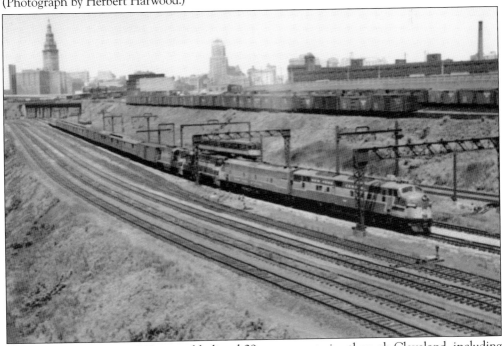

The October 24, 1959, NYC timetable listed 29 passenger trains through Cleveland, including four that did not serve CUT. Most trains operated on the Water Level Route between Chicago and New York, including seven that originated or terminated in Cleveland. One pair operated between Cleveland and St. Louis, two between Cleveland and Indianapolis, and three between Cleveland and Cincinnati. Shown is No. 234 in June 1960. (Photograph by Herbert Harwood.)

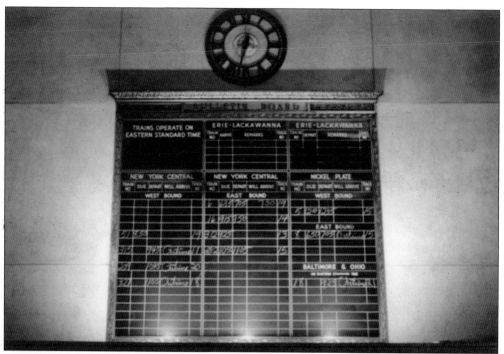

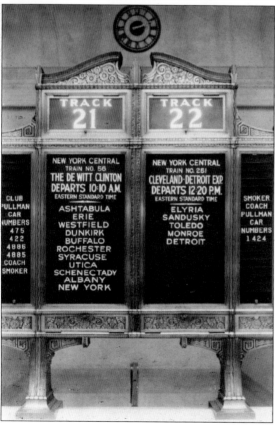

Travelers and visitors could check the status of trains on the CUT bulletin board where station personnel wrote in chalk the latest information. The above photograph taken in February 1962 at 6:30 p.m. shows trains scheduled for that evening. Passengers boarded from a concourse area that had stairways leading down to the platforms below. For each doorway, there was an ornate train-information stand that showed the train number, name, and select cities served by that train. Also shown was the location of the cars in the train. Therefore, a passenger holding space in sleeper No. 4885 could tell at a glance where that car was in the makeup of NYC train No. 56. When a train was ready for boarding, a gateman opened the doors to the stairway. (Above, photograph by Herbert Harwood; left, Cleveland State University Library Special Collections.)

The NYC's oval-shaped logo dated to 1893, although its interior design was tweaked over the years. In 1959, the NYC adopted a new logo, which became known as the "cigar band logo." Freight and passenger locomotives were repainted between 1960 and 1962 into a minimalist black livery, with freight locomotives featuring a white stripe on their lower flanks. Shown is GP9 No. 7392 working during the mid-1960s. (Cleveland State University Library Special Collections.)

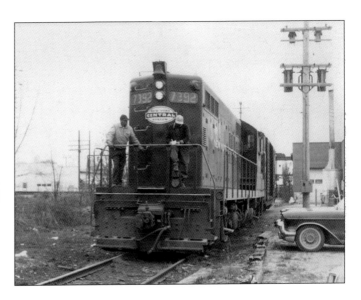

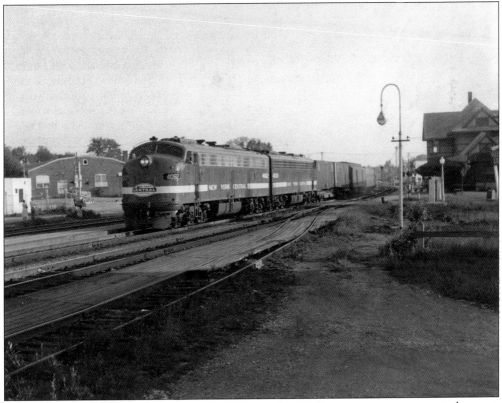

The *Ohio State Limited*, shown on June 3, 1967, was the NYC's premier passenger train between New York and Cincinnati. It featured sleepers, coaches, a diner, and, until October 1956, a lounge-observation car. Nos. 15 and 16 were discontinued between Cleveland and Buffalo on November 5, 1967. The Cleveland-Cincinnati segment continued as an all-coach train until the Columbus-Cincinnati leg was discontinued in 1969, ending direct Cleveland-Cincinnati rail passenger service. (Cleveland State University Library Special Collections.)

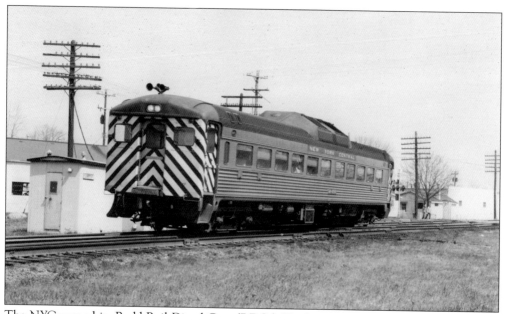

The NYC named its Budd Rail Diesel Cars (RDCs) "Beeliners." In the early 1960s, a daytime train named the *Miami Valley Beeliner* operated from Cleveland to Cincinnati. There was no corresponding return train, so the RDC equipment returned empty or was attached to another train, probably the *Night Special*. RDCs returned to the Cleveland-Cincinnati route in late 1967 upon the discontinuance of the *Ohio State Limited* east of Cleveland. (Cleveland State University Library Special Collections.)

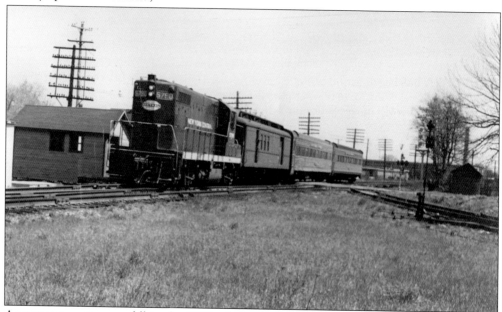

As passenger patronage fell in the 1960s, the NYC reduced passenger train consists to a bare-bones operation. Shown is a typical consist of the mid-1960s—a GP7 locomotive, a railway post office, and two coaches. NYC ended its last direct service between Cleveland and St. Louis on September 6, 1967, by ending the westbound *Knickerbocker* and eastbound *Southwestern* between Cleveland and Union City, Indiana. (Cleveland State University Library Special Collections.)

Four

NICKEL PLATE ROAD

The New York, Chicago & St. Louis Railroad (NYC&St.L) was founded on February 3, 1881, by a syndicate headed by New York financier George I. Seney. Originally planning to build between Cleveland and Chicago, with a branch to St. Louis that diverged at Fort Wayne, Indiana, the NYC&St.L dropped the St. Louis extension idea in favor of building from Cleveland to Buffalo, New York.

Built in 500 days for $23 million, the last piece of the NYC&St.L to be completed was the swing bridge over the Cuyahoga River in Cleveland, which opened on September 1, 1882. The NYC&St.L acquired two suburban railroads—the Rocky River Railroad and the Cleveland, Painesville & Ashtabula Railroad (CP&A)—to help gain passage through Cleveland.

The CP&A had begun as the 6.8-mile Lake View & Collamer Railroad, opening on May 1, 1875, between Becker and Superior Avenues in Cleveland, and Euclid Village. The CP&A was not part of an LS&MS predecessor railroad of the same name that had been built earlier east of Cleveland.

The NYC&St.L operated as the "Nickel Plate Road" (NKP). That name is credited to a newspaper editorial published on March 10, 1881, in the *Norwalk Chronicle*, in which editor F.R. Loomis wrote of "the great New York and St. Louis double track, nickel plated railroad." At the time, the word "nickel" was used interchangeably with silver to denote something of value. Three days after its completion, the NKP was sold for $7 million to agents representing William K. Vanderbilt, whose family controlled the LS&MS. This fueled speculation that the NKP had been built to force the Vanderbilts to buy a competitor.

The NKP stagnated under Vanderbilt control, and to avoid antitrust problems, it was sold in 1916 to a pair of Cleveland bachelor brothers: Oris P. and Mantis J. Van Sweringen. Under their control, the NKP thrived and was headquartered in Cleveland. The Van Sweringens merged the NKP with the Lake Erie & Western Railroad (LE&W) on January 11, 1922, and with the Toledo, St. Louis & Western Railroad on December 28, 1922. Neither of those roads had directly served Cleveland.

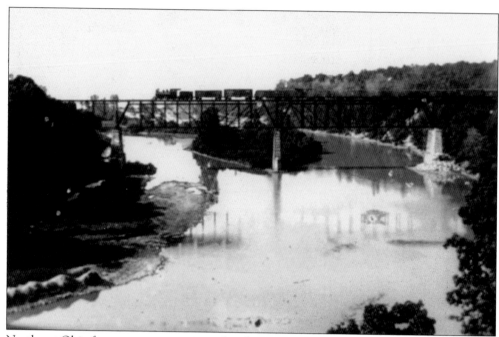

Northeast Ohio features numerous rivers that flow into Lake Erie, and the NKP crossed most of them on impressive-looking wrought-iron bridges. To cross the Rocky River gorge at Rockport (now Rocky River), the NKP in 1882 built a multiple-span Bollman truss bridge that measured 673 feet in length and 88 feet in height. An NKP train is shown crossing the Rocky River Bridge in the 1890s. (Cleveland State University Library Special Collections.)

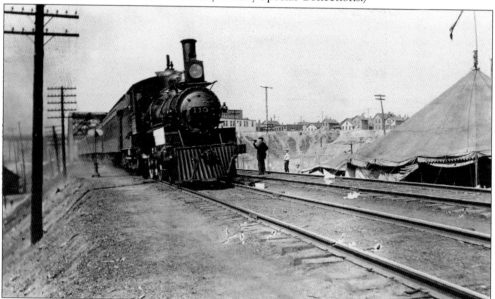

In its first decade, the NKP offered only local passenger service. Its first Chicago-Buffalo train was the *Chicago Express/Buffalo Express*, which debuted October 23, 1892, on an overnight schedule. An NKP train is shown in the Cleveland Flats in 1910. The tent at the right side of the photograph suggests this might have been a chartered train bound for a special event. (Craig Sanders collection.)

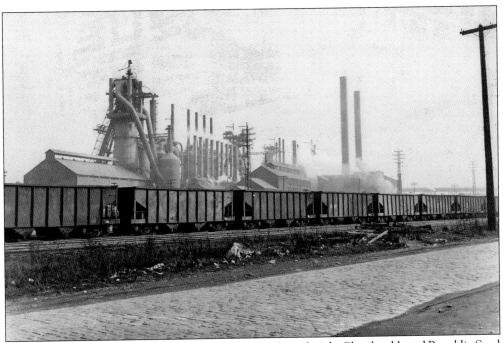

Cleveland's steel mills were a rich source of traffic for the railroads. Cleveland-based Republic Steel Corporation was established on April 8, 1930, by combining various steel companies, including two Cleveland steel companies. Republic was once the nation's third-largest steelmaker, and by 1965, the Cleveland Works was its largest mill. Railroad hopper cars fed coke and iron ore to the blast furnaces of the Cleveland Works. (Cleveland State University Library Special Collections.)

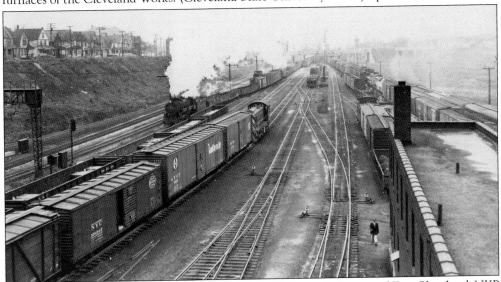

CUT tracks paralleled the NKP between about East Fourteenth Street and East Cleveland. NKP passenger trains used CUT tracks for four miles between East Thirty-seventh and West Thirty-eighth Streets, and the NYC leased two NKP tracks for use by NYC passenger trains between East Thirty-seventh Street and Fairmount Road. The CUT tracks are shown in this image at the far left on the north side of the NKP's Fifty-fifth Street Yard. (Cleveland State University Library Special Collections.)

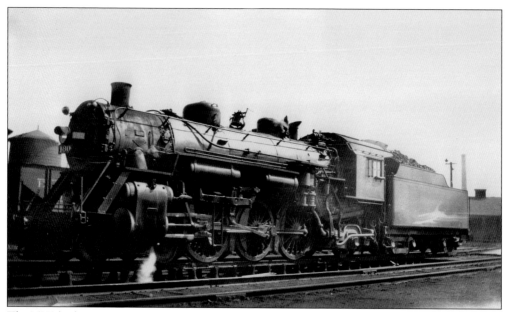

The NKP had 10 Pacific-type 4-6-2 locomotives. This one, No. 160, was built by Lima in December 1922. Lima produced four of the NKP's Pacifics, and Alco built the other six. This was the third and last NKP steam locomotive to carry the 160 number. Pictured here between assignments in Cleveland on March 29, 1929, it was sold for scrap on May 29, 1953. (Cleveland State University Library Special Collections.)

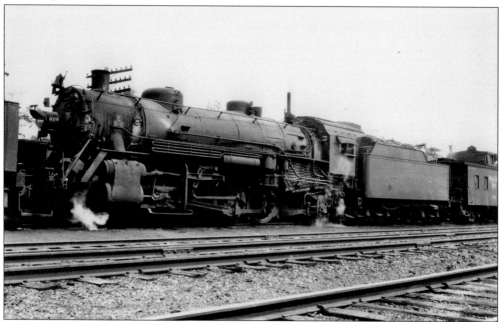

In October 1918, the USRA assigned the NKP 10 Mikados, including No. 606 (shown here with a caboose in Lorain on June 2, 1929). The USRA Mikados performed so well that the NKP ordered 61 additional "Mikes" from Lima, which were delivered between 1920 and 1924. No. 606 was built by Alco in October 1918 and sold on October 1, 1945, to Ferrocarriles Nacionales de México, the national railroad of Mexico. (Cleveland State University Library Special Collections.)

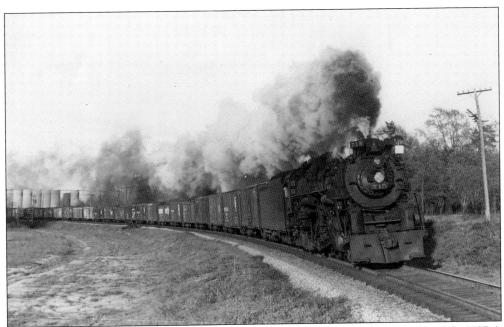

The Lima S-class Berkshire was an effort to improve upon the speed and horsepower of the USRA 2-8-2 Mikado, a successful World War I–era design. Lima gave the S class two additional trailing wheels to support a larger firebox and boiler, enabling the locomotive to sustain steam at speed over long distances. The NKP Berkshires were a smaller version of C&O's 2-10-4 Texas type. Like the NKP, the C&O was owned by the Van Sweringens, and development of new equipment for all of their railroads was overseen by the Advisory Mechanical Committee. The NKP purchased 80 Berkshires between 1934 and 1949. They are, arguably, the best known of their type. Historian Eugene Huddleston described the NKP Berkshires as "the greatest 2-8-4s ever to take to the rails." Two Berkshires are shown working in these photographs. (Both, Cleveland State University Library Special Collections.)

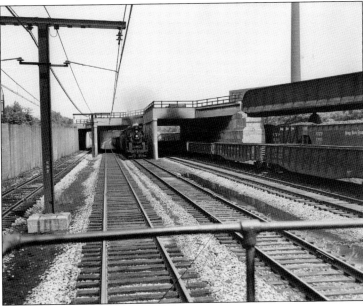

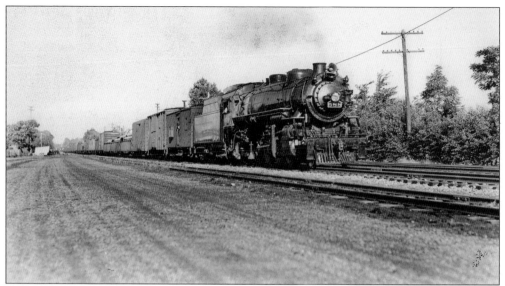

The NKP owned 141 Mikados, 15 of which it inherited when it acquired the LE&W in 1923. These were built by Baldwin in September 1918. Three NKP Mikados survive. The best known is No. 587, which pulls excursion trains for the Indiana Transportation Museum. Also saved were Nos. 629 and 634. In this image, No. 588 is shown pulling a freight train in Cleveland around 1935. (Cleveland State University Library Special Collections.)

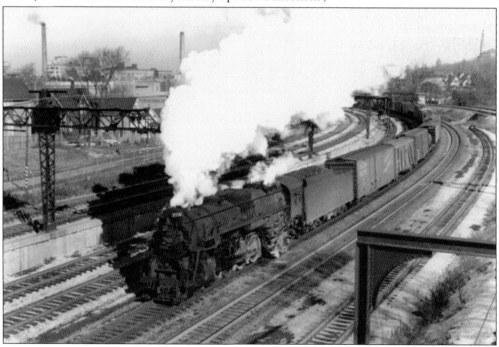

Four railways passed over Cedar Glen Parkway when this 1957 photograph of a westbound NKP freight train was made. These included tracks of the CUT (far left), the NYC's Short Line, and the Cleveland Transit System's Rapid Line between CUT and Windermere (far right). That line opened on March 15, 1955, and today is part of the Red Line of the Greater Cleveland Regional Transit Authority. (Photograph by Herbert Harwood.)

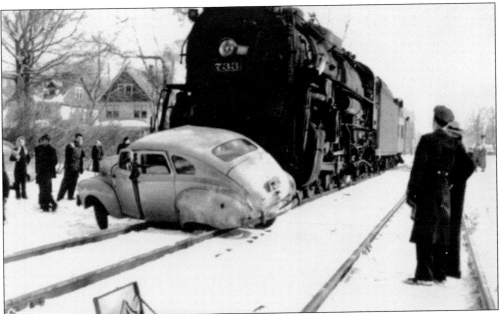

Lakewood had more than 25 grade crossings with the NKP in one of the most densely populated cities in Cuyahoga County. By the early 2000s, all Lakewood crossings had crossing gates, and a limited number of trains used the former NKP. The information with this photograph did not indicate if there were any injuries in this accident involving an NKP 2-8-4 Berkshire pulling a caboose and a 1937 Ford. (Cleveland State University Library Special Collections.)

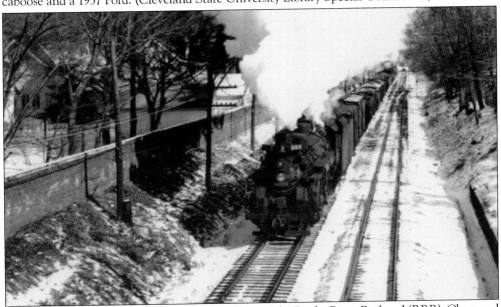

The NKP traversed Lakewood on the right-of-way of the Rocky River Railroad (RRR). Chartered on January 11, 1867, the 5.58-mile RRR opened by 1868 between Cleveland's Bridge Street and Waverly Avenue (now West Fifty-eighth Street) and today's Sloane Avenue in Lakewood's Clifton Park neighborhood on the east bank of the Rocky River. Clifton Park was then a summer resort. Here, a westbound NKP freight passes through Lakewood around 1949. (Cleveland State University Library Special Collections.)

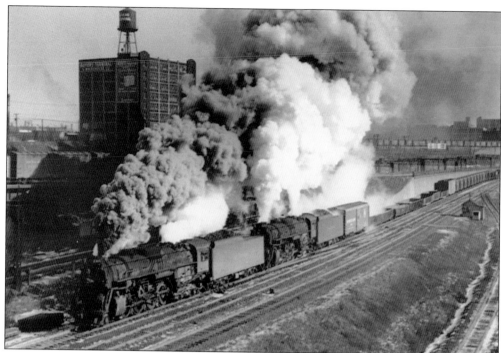

Steam locomotives were impressive to watch, particularly when they were belching smoke and steam. But they were expensive and labor-intensive when compared with diesels, and that led to their demise. The NKP still believed in steam power and produced operating data to show that steam performed as well as the diesels that manufacturers were trying to sell. In 1949, the NKP placed with Lima its last order for steam locomotives. NKP management expected to eventually retire its steam locomotives, but not until 1962. The recession of 1957 to 1958 hastened those plans. Images such as that above, made in 1957 at old Broadway Avenue of a steam doubleheader, soon faded away. In the image below, No. 643, a 2-8-2 Mikado, passes two Shaker Rapid cars at East Thirty-fourth Street in November 1954. (Both photographs by Herbert Harwood.)

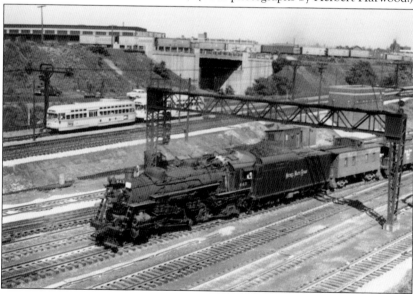

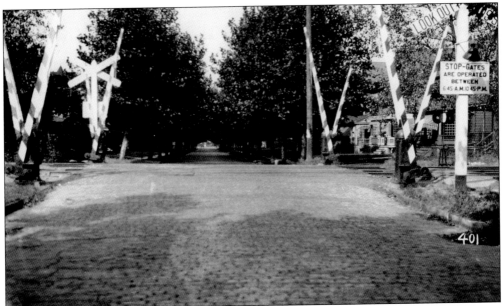

Early crossing gates were manually operated by a watchman who often passed the time between trains in a nearby shanty. It was not unusual for crossing watchmen to be railroad-operating employees who could no longer serve as engineers, brakemen, or conductors due to health issues or disability. At this NKP crossing in 1922, the gates were only operated between 6:45 a.m. and 10:45 p.m. (Cleveland State University Library Special Collections.)

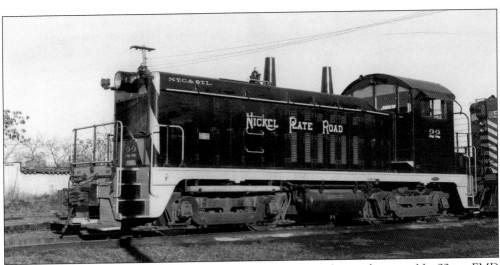

The NKP's first diesel locomotives were switch engines assigned to yard service. No. 22, an EMD NW2, was part of a second wave of switchers that the NKP ordered between 1947 and 1948. It was built in February 1948 and continued in service after the 1964 merger with the Norfolk & Western Railway (N&W). Renumbered 2022 in February 1968, it was retired by the N&W on September 18, 1979. (Cleveland State University Library Special Collections.)

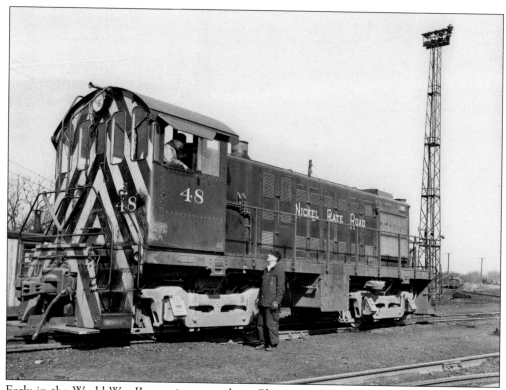

Early in the World War II era, city councils in Chicago and Buffalo enacted ordinances that forced railroads to reduce locomotive smoke. In response, the NKP ordered 10 diesel switchers, six S-2s from Alco, and four NW2s from EMD, for yard service in those cities. It was five years before the NKP acquired additional diesel switchers. No. 48 (shown above) is an S-4 built by Alco in December 1950. After the N&W merger, NKP locomotives with double-digit roster numbers were given "20" before their original number. No. 48 thus became No. 2048 in November 1966. No. 28 (shown below) is still wearing the all-black livery that it had when it came out of the Alco factory in May 1947. Never renumbered by the N&W, it was retired on September 6, 1966, and eventually scrapped. (Both, Cleveland State University Library Special Collections.)

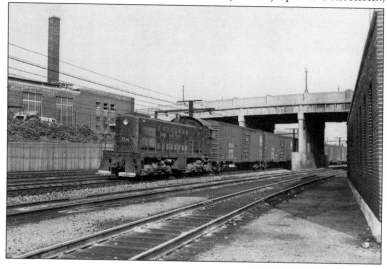

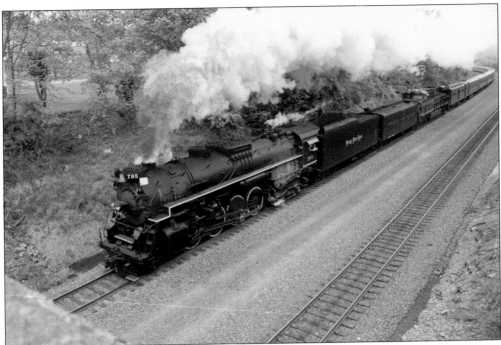

No. 765 was built in 1944 and retired in 1958. Donated to the city of Fort Wayne, Indiana, the 2-8-4 Berkshire was restored to operating condition in 1979. It has hauled excursions over various railroads, including the former NKP route in Cleveland. Large crowds line the tracks whenever it pulls an excursion. For many, it is their first look at what was once commonplace throughout America. (Photograph by Craig Sanders.)

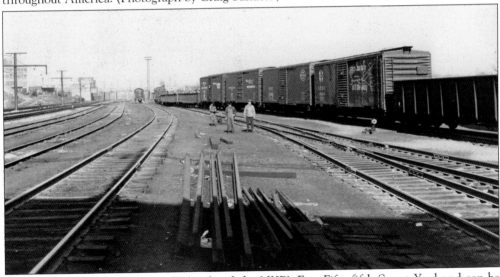

The Shaker Heights Rapid tracks bordered the NKP's East Fifty-fifth Street Yard and can be seen at the far left in this photograph. Established by the Van Sweringen brothers, the Shaker Heights Rapid eventually became the Green and Blue Lines of the Greater Cleveland Regional Transit Authority (RTA). Cleveland RTA today has its maintenance and repair shops at this location adjacent to the remains of the former NKP yard. (Cleveland State University Library Special Collections.)

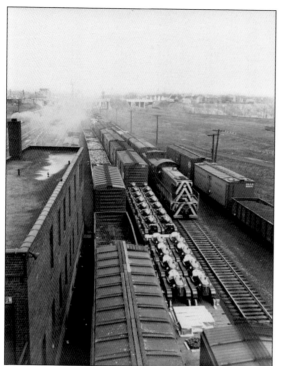

A 1954 NKP report titled "Physical Data and Other Information of Interest" listed seven yards in Cleveland for the switching and classification of cars. The principal yard was located at East Fifty-fifth Street, which is shown in the images here. This yard had a capacity of 630 cars. Other yards and their car capacity included Euclid (671 cars), Ivanhoe Road (230 cars), Food Terminal (460 cars), Concentration Yard (located south of the Food Terminal; 320 cars), Broadway Yard (380 cars), and West 110th Yard (260 cars). The NKP also maintained freight stations at Euclid, Ivanhoe Road, East Seventy-fifth Street, East Ninth Street (principal freight house), West Twenty-fifth Street, West 110th Street, and in Rocky River. The photograph below was taken at the west edge of the East Fifty-fifth Street Yard. The CUT tracks ran on the yard's north side. (Both, Cleveland State University Library Special Collections.)

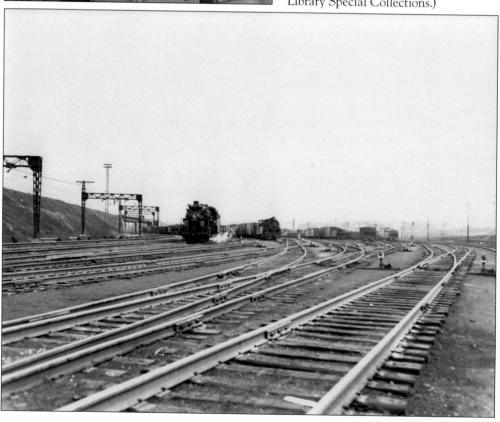

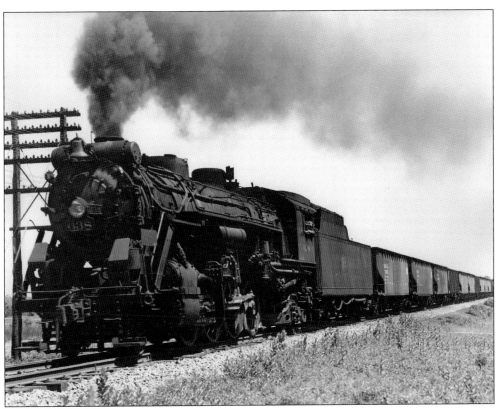

The NKP had a fast, efficient freight route between Chicago and Buffalo. Much of the freight traffic was through shipments picked up from one railroad and handed off to another at each end of the route. The NKP's relatively flat profile, with long sections of tangent tracks, enabled it to boast of high-speed freight service, a selling point that the railroad emphasized following World War II. (Cleveland State University Library Special Collections.)

Cleveland is well known for receiving lake-effect snow from Lake Erie, particularly on the east side of the metropolitan area. The railroads were used to dealing with snow, but it still could create operating problems when it clogged switches and had to be dug or swept out. This scene of the NKP's Fifty-fifth Street Yard captures just another winter day on the railroad. (Cleveland State University Library Special Collections.)

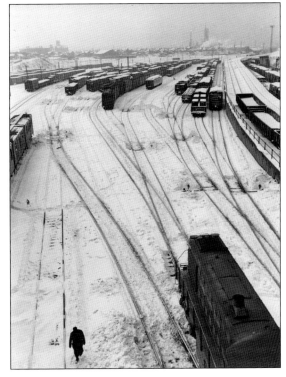

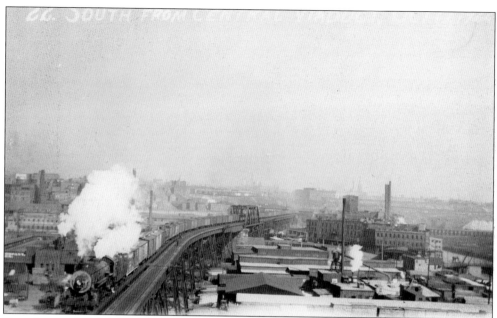

Completion of a 3,000-foot viaduct over the Cuyahoga River was the last step in the construction of the NKP's Chicago-Buffalo route. The original plan was to cross the river on a low-level bridge and bore a tunnel into the west side of the Cuyahoga gorge. This was dropped in favor of a bridge that soared 68 feet above the valley floor. Work on the masonry piers was completed in May 1882, and it took most of the summer to put into place the iron towers and girder spans. The draw span over the river was completed in August 1882. It was the country's longest viaduct at the time. The NKP undertook heavy pier repairs and girder renewal in 1944. Until the CUT viaduct was built in 1929, the NKP was the only railroad crossing the Cuyahoga on a high bridge. (Both, Cleveland State University Library Special Collections.)

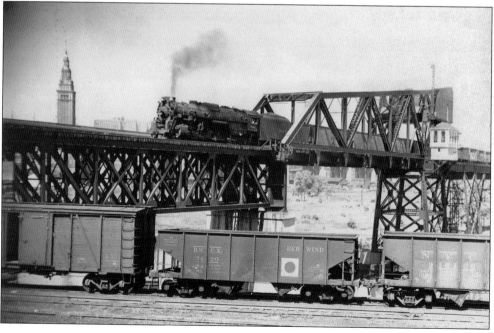

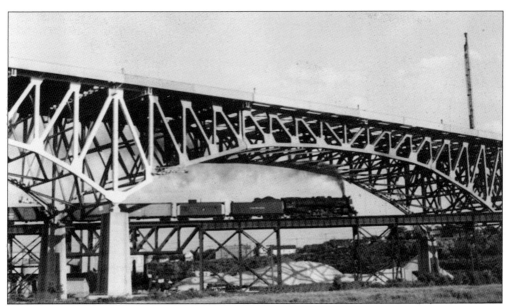

The original NKP bridge swing span over the Cuyahoga River took four minutes to open by hand, but steam power later did the job in a minute. A 167-foot Scherzer rolling lift bridge was installed in 1907. Construction began in 1955 on a 267-foot vertical lift bridge, which was built for $5 million as part of a $21-million project funded by the railroads and federal government to widen the river and improve marine navigation. The project involved replacing six road and railroad bridges. The Inner Belt Bridge carrying Interstate 90 over the NKP bridge and the Cuyahoga River valley was under construction in June 1957 when these images were made. The Inner Belt Bridge stands in the approximate location of the former Central Viaduct, which opened in 1888 and was closed in 1941. (Both photographs by Herbert Harwood.)

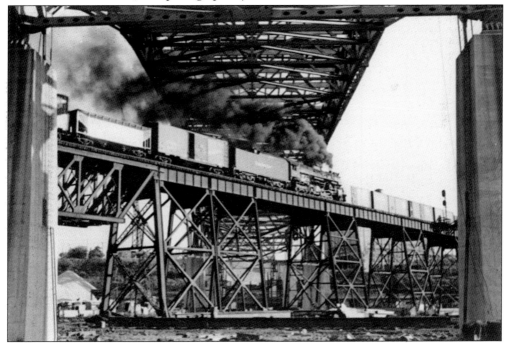

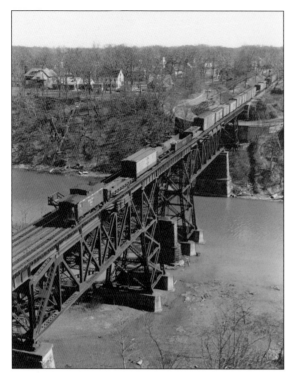

The NKP bridge over the Rocky River gorge was replaced in 1907, the same year that the NKP also rebuilt the bridge over the Cuyahoga River. The Rocky River Bridge featured a double-track steel structure with girders and trusses 697 feet in length. In 1953, the towers were strengthened, and the girders renewed. The NKP also had high steel bridges in Northeast Ohio at Painesville (over the Grand River), Ashtabula (over the Ashtabula River), and Conneaut (over Conneaut Creek). The photograph at left shows a freight train crossing the Rocky River Bridge on March 22, 1958. The undated photograph below shows a trailer on a flatcar train crossing the bridge. Such trains are also called intermodal trains because they are designed to move freight over various modes of transportation—in this case, by rail and by highway. (Both, Cleveland State University Library Special Collections.)

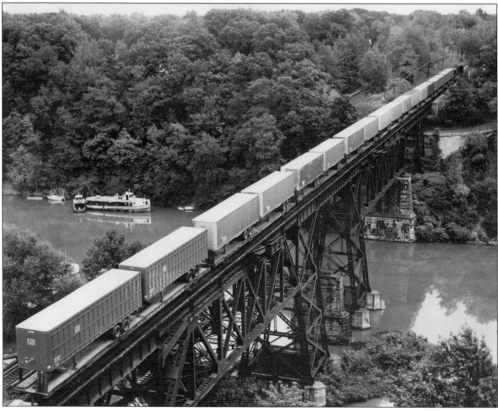

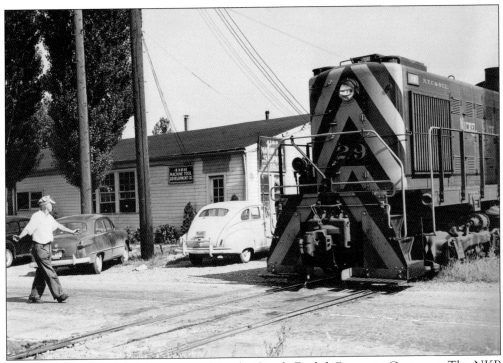

The Euclid Railroad (ER) was owned by the South Euclid Concrete Company. The NKP sent a switcher from Ivanhoe Road Yard to deliver or pick up cars. In 1950, the ER served 18 customers who shipped stone, cement, lumber, cinders, peat moss, slag, and salt. It connected with the NKP in Euclid and extended 1.59 miles southeastward to near Monticello Boulevard in South Euclid. The track was located east of Green Road. The ER began losing money in 1962, and the N&W, which had acquired the NKP in 1964, refused to provide service until the railroad rehabilitated its tracks. Rather than spend the $23,600 needed for that, the ER sought abandonment, which the Interstate Commerce Commission granted on March 29, 1967. Shown below is an NKP crewman stopping traffic at Euclid Avenue on August 30, 1950. (Both, Cleveland State University Library Special Collections.)

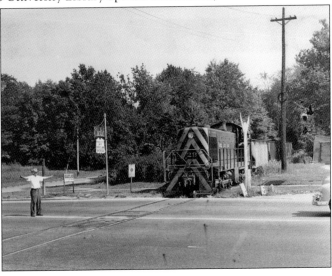

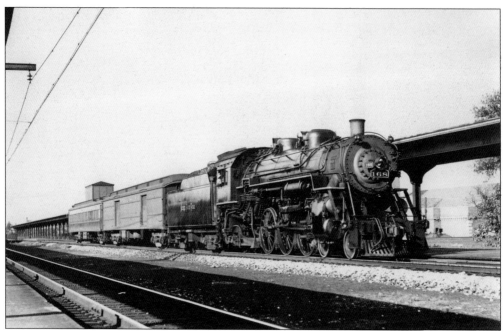

In the 1890s, the NKP expanded Chicago-Buffalo service to three round-trips that it billed as the "Peerless Trio." Advertisements showed a hand holding three trains and a banner proclaiming "excellent dining service." The 1893 World's Columbian Expedition in Chicago prompted the NKP to offer through-car service between Chicago and New York, exchanging the cars in Buffalo with the West Shore Railroad (later NYC). After the fair closed, the through car arrangement shifted to the Delaware, Lackawanna & Western Railroad. Local passenger trains still played a significant role in the NKP through the 1930s. In the photograph above, a two-car train calls at East Cleveland in an undated photograph. The same locomotive, Alco K-1B No. 168, is shown below pulling a nine-car train in Cleveland. The 4-6-2 locomotive was built in August 1923, retired in November 1951, and scrapped in August 1952. (Both, Cleveland State University Library Special Collections.)

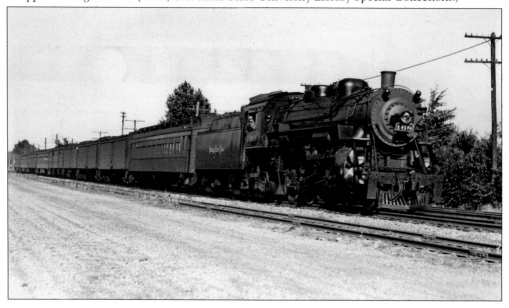

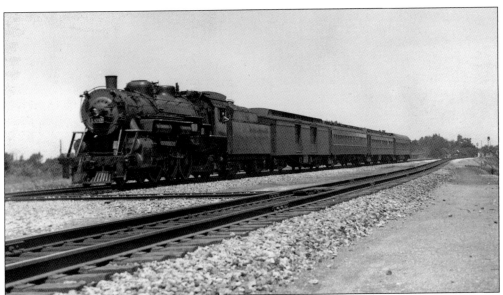

Nos. 9 and 10 began service between Cleveland and St. Louis on February 19, 1928, and were the only NKP trains to operate over all three NKP predecessor railroads. They were also the last passenger trains to operate on the former Clover Leaf and LE&W. Assigned K-1 Pacific-type steam 4-6-2 locomotives in 1930, Nos. 9 and 10 received PA-1 diesels on March 21, 1948. Here, No. 169 pulls St. Louis–bound No. 9. (Cleveland State University Library Special Collections.)

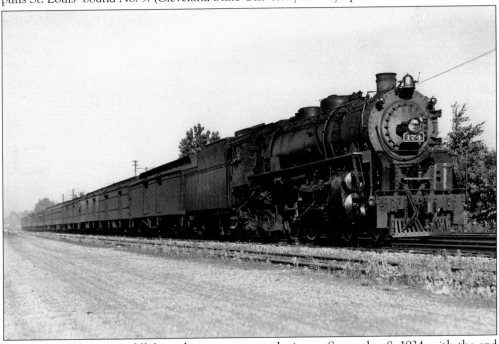

Chicago-Buffalo service fell from three to two round-trips on September 8, 1934, with the end of Nos. 3 and 4. The survivors included the *Nickel Plate Limited* and Nos. 7 and 8. No. 7 was named the *Westerner*, while No. 8 became the *New Yorker* on October 28, 1956, a name chosen to match its DL&W counterpart. No. 7 is shown in Cleveland on May 26, 1935. (Cleveland State University Library Special Collections.)

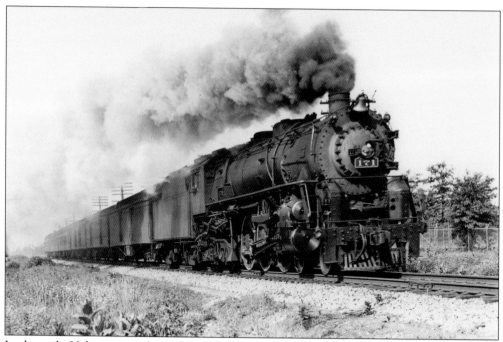

In the early 20th century, the 28-hour Chicago–New York schedule of the *Nickel Plate Express* was eight hours slower than the premier NYC and PRR trains. Railroads in the Chicago–New York market charged extra fare for trains making the trip in less than 28 hours. For each hour below that, the fare rose by $1.20. The NKP's best Chicago–New York time was 20 hours and 35 minutes in the late 1940s, but the crack expresses of the NYC and PRR were four hours faster. The connecting DL&W route east of Buffalo was shorter than the NYC, but it was slower because of curves and steep grades. Also, DL&W trains terminated in Hoboken, New Jersey. In the photograph above, No. 6 is at Cleveland on June 14, 1939. In the photograph below, No. 6 is shown at Euclid on June 8, 1939. (Both, Cleveland State University Library Special Collections.)

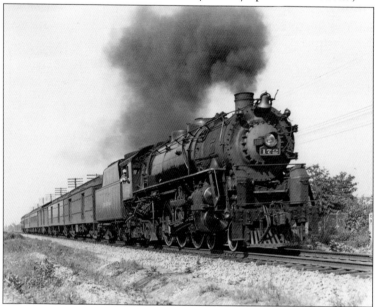

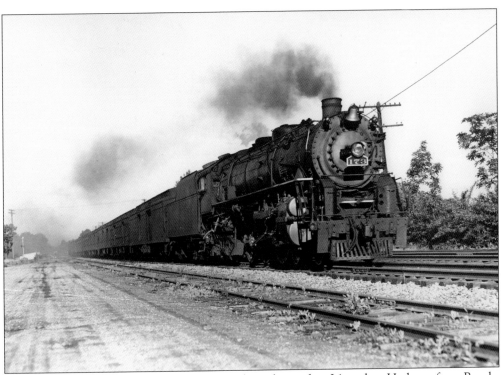

The NKP began upgrading passenger service by ordering four L1-a–class Hudsons from Brooks Locomotive Works, which were built in March 1927. Two years later, it purchased 21 all-steel passenger cars from Pullman. The order included eight coaches, three diners, two café-parlor cars, and eight baggage and mail cars. The NKP purchased four additional Hudsons, which were built in November 1929 by Lima. NKP passenger trains were pulled by CUT P-1a electric locomotives for three miles. For a westbound train, the steam locomotive was replaced by an electric locomotive at East Thirty-eighth Street. The steamer ran past CUT and rejoined its train at Cloggville, where the NKP tracks diverged from CUT tracks. No. 173 is shown above on June 3, 1934, with No. 6 in Cleveland. The photograph below was made the same date but at a location farther west. (Both, Cleveland State University Library Special Collections.)

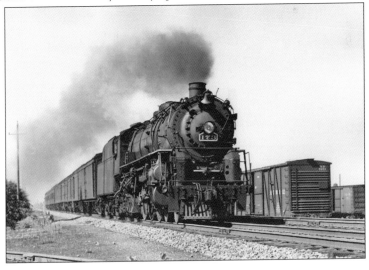

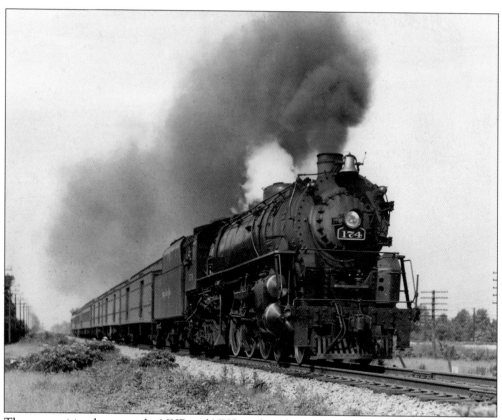

The competition between the NKP and NYC in the Chicago-Cleveland market was intense. In 1928, NKP No. 5 and the NYC's *Forest City* each departed Cleveland at 11:30 p.m. The *Forest City* made just three intermediate stops and arrived at Chicago's LaSalle Street Station 15 minutes ahead of its NKP counterpart. After the NKP upgraded the equipment on the *Nickel Plate Limited* in April 1929 and reduced its running time, the NYC cut its Chicago-Cleveland running times, added additional sleeping cars, and announced plans for new equipment for the *Forest City*. Because the NKP could not match the NYC's number of trains or its deep pockets to spend on equipment, it sought to offer better onboard service. The NKP also operated a sleeper that operated between Cleveland and Fort Wayne, Indiana, a distance of 188 miles. (Both, Cleveland State University Library Special Collections.)

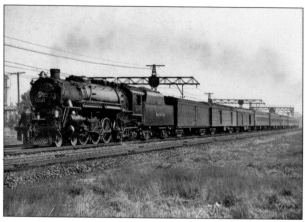

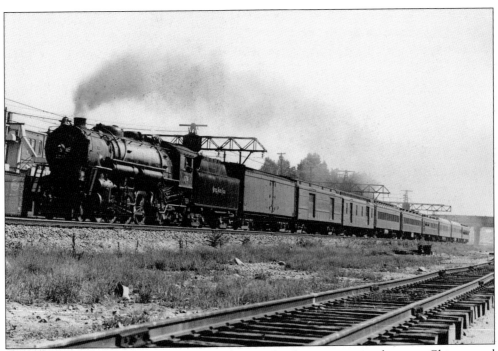

The NKP's first lightweight cars were two sleepers that began operating between Chicago and Cleveland on August 4, 1940. Named *Moses Cleaveland* and *Robert de La Salle*, each car contained 18 roomettes. The NKP ordered 25 stainless-steel lightweight cars from Pullman-Standard in 1947. The order included 10 coaches, 2 bedroom/lounge/diners, and 13 sleepers. That same year, the NKP ordered its first passenger diesels. The Hudsons were relegated to backup duty on mainline trains, while K-1 Pacifics replaced R-class 4-6-0 locomotives on branchline trains. Following World War II, the NKP fielded 10 intercity passenger trains, including six that served Cleveland. The high-water mark for NKP passenger service had been April 28, 1929, when it offered 28 passenger trains and 11 mixed trains. By 1960, though, NKP passenger service had fallen to four Chicago-Buffalo trains. (Both, Cleveland State University Library Special Collections.)

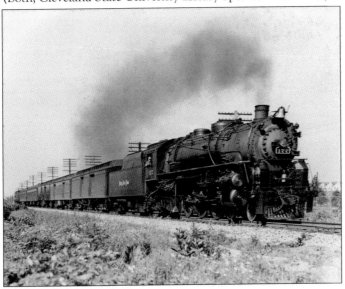

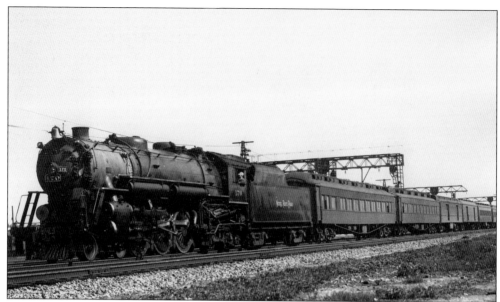

Before moving its passenger trains to CUT, the NKP had a station on Broadway Avenue and another depot on Euclid Avenue. The Erie–DL&W merger of 1960 did not immediately affect the NKP's Chicago–New York through car service aside from resulting in former Erie cars being assigned to the pool. The Chicago–New York sleepers ceased operating west of Cleveland on August 6, 1962. A Chicago-to–New York coach conveyed by the *City of Cleveland* ended shortly after the *New Yorker* and *Westerner* last ran June 2–3, 1963, thus ending through service east of Buffalo. Nos. 5 and 6, the *City of Chicago* and *City of Cleveland* respectively, had been the *Nickel Plate Limited* before being renamed in September 1954. The *City of Chicago* is shown below just before it was discontinued on September 10, 1965. (Above, Cleveland State University Library Special Collections; below, Craig Sanders collection.)

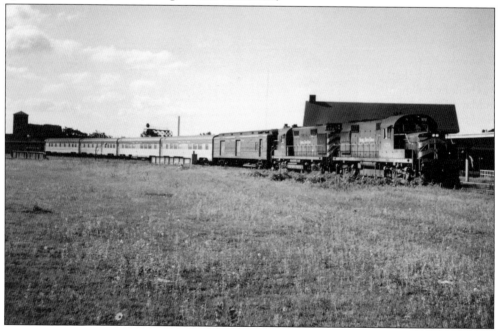

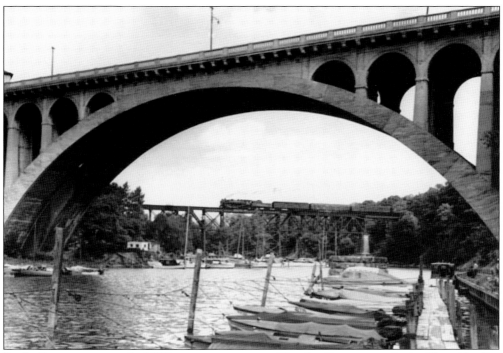

Rocky River was a stop for NKP passenger trains in Cleveland's western suburbs. Here, No. 7 is approaching the Rocky River depot. The bridge in the foreground carries Detroit Road over the river. No. 7 was scheduled into the Rocky River depot at 10:00 a.m. The station was located just west of the river on Depot Street. The station is now gone, but the street name remains today. (Cleveland State University Library Special Collections.)

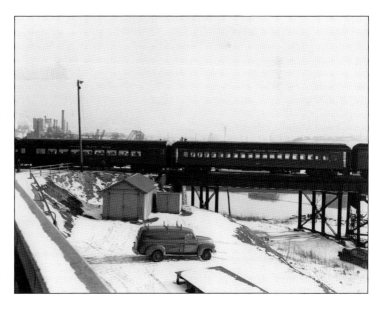

It is a tale of two coaches. No. 85 (left) was built by Pullman in May 1923 whereas No. 96 was built by Pullman in January 1930. No. 85 was rebuilt in 1946 to resemble a modern, streamlined coach. It went from 80 to 52 seats. No. 96 has 80 seats, including a 22-seat smoking section with leather upholstery rather than the plush fabric found elsewhere in the car. (Cleveland State University Library Special Collections.)

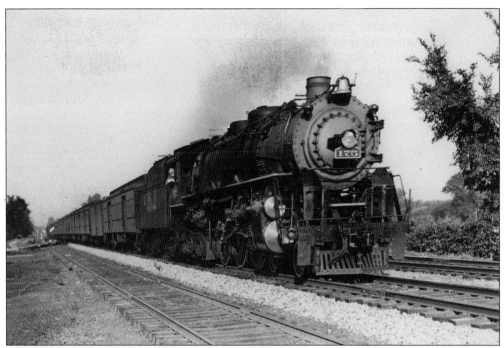

Hudsons displaced from scheduled passenger trains found a second life pulling baseball specials, employee specials, and excursions sponsored by National Railway Historical Society chapters and other railroad clubs. No. 175, shown here pulling a regularly scheduled train in the 1930s, drew the honor of pulling the last steam-powered passenger train on the NKP's east end, a trip from Cleveland to Buffalo and a return on May 18, 1958. (Cleveland State University Library Special Collections.)

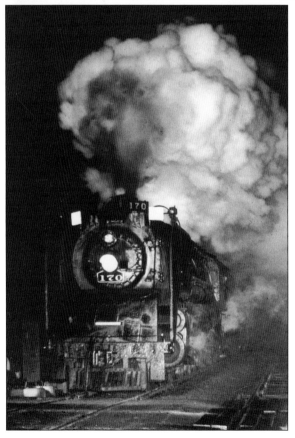

Movie enthusiasts boarded an 11-car special in Fostoria, Ohio, on February 9, 1957, to journey to Cleveland to watch films presented in Cinerama. The train is shown passing through Bay Village on the return trip in the rain. The white flags on the locomotive denote that this is an extra, not a scheduled train. These trains usually carried heavyweight and rebuilt heavyweight coaches. (Cleveland State University Library Special Collections.)

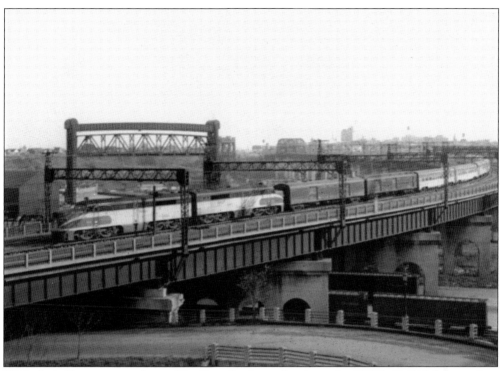

With their blue noses and metallic silver flanks and stripes, the NKP's 11 PA1 locomotives were dubbed "Bluebirds." The first seven of them arrived in December 1947, with Nos. 180–182 being placed into service at Cleveland. The Bluebirds were standard motive power on mainline passenger trains for more than a decade, usually operating in pairs on Chicago-Buffalo trains. In the photograph above, No. 8 sails over the Cleveland Flats in May 1956. No. 8 was named the *New Yorker* on October 28, 1956. The photograph below provides an earlier view of No. 8, showing it at the East Cleveland Station. The NKP sold the Bluebirds to Alco in November 1961 and leased them back on a monthly basis. Nos. 181 and 186 were the last to serve the NKP, leaving for good in May 1962. (Both photographs by Herbert Harwood.)

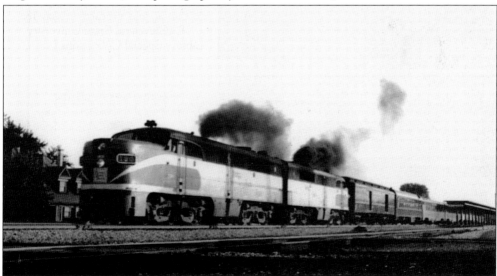

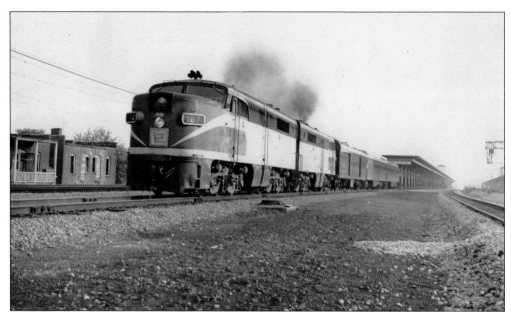

NKP passenger service was in its final years by June 2–3, 1963, when the *Westerner* (No. 7) and the *New Yorker* (No. 8) began and completed their final trips. The last NKP passenger trains, the *City of Chicago* (No. 5) and the *City of Cleveland* (No. 6) ended on September 10, 1965. In their final years, these trains usually carried a railway post office, two coaches, a sleeper (operating Chicago-Cleveland only), and a buffet-lounge-sleeper. (Cleveland State University Library Special Collections.)

The NKP offered commuter service between Cleveland and Rocky River until June 2, 1963. In this image, an eastbound train crosses the bridge over the Rocky River in about 1959. Leading the two-car train is GP9 No. 477. Built in July 1955, it was retired in April 1985 after spending most of its life in freight service. Also in the train consist is a heavyweight coach. (Cleveland State University Library Special Collections.)

CUT (shown here) was the terminus of Nos. 9 and 10, an NKP overnight train between Cleveland and St. Louis. Named the *Blue Dart* and *Blue Arrow* respectively on October 28, 1956, Nos. 9 and 10 last operated to St. Louis on March 14, 1959. The trains continued running between Cleveland and Coldwater, Ohio, by order of Ohio regulatory authorities, but made their final runs on October 17, 1959. (Cleveland State University Library Special Collections.)

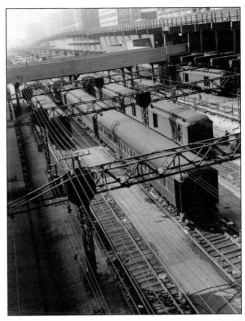

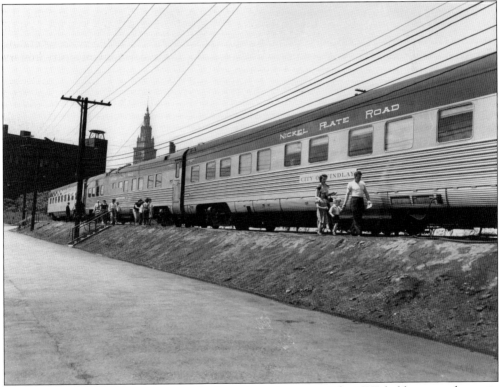

Railroads sought to attract passenger business in various ways. The NKP held an open house in June 1950 at its Cleveland coach yard to show off its new passenger equipment, including the *City of Findlay* (right), which had 10 roomettes and 6 double bedrooms. The *City of Chicago* (in the center) was a buffet-lounge with five double bedrooms. Both cars were built by Pullman Standard in 1950. (Cleveland State University Library Special Collections.)

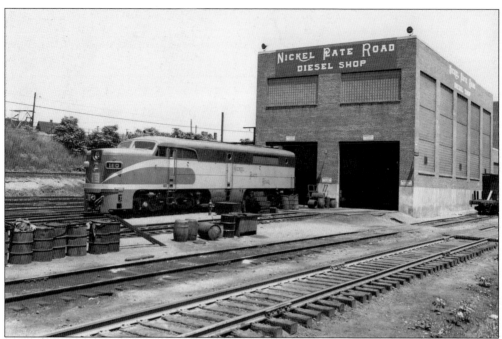

The NKP maintained a small engine terminal at East Seventy-fifth Street. The diesel shop was built in 1948. In the photograph above, PA1 No. 180, which was built by Alco in December 1947 as part of an order for seven passenger locomotives, is at the diesel shop for servicing. The NKP sold No. 180 back to Alco in November 1961 and removed it from the roster in March 1962; it was then scrapped. The photograph below shows the interior of the shop, where two switch engines are receiving service. No. 31, at right, is an Alco S-2 that was built in June 1947 and retired by the NKP on November 1, 1966. (Both, Cleveland State University Library Special Collections.)

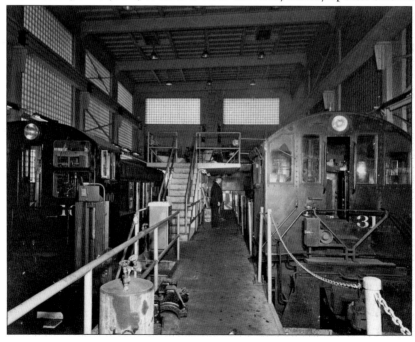

A shop worker makes repairs to switcher No. 100 at the NKP's East Seventh Street diesel shop. No. 100 is a DS4-4-100 built by Baldwin in October 1947. It served the NKP for nearly 20 years before being retired in August 1966. It was then sold and eventually scrapped by Columbia Iron & Metal Company. (Cleveland State University Library Special Collections.)

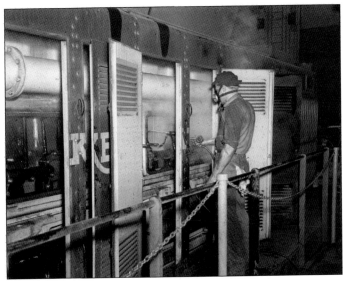

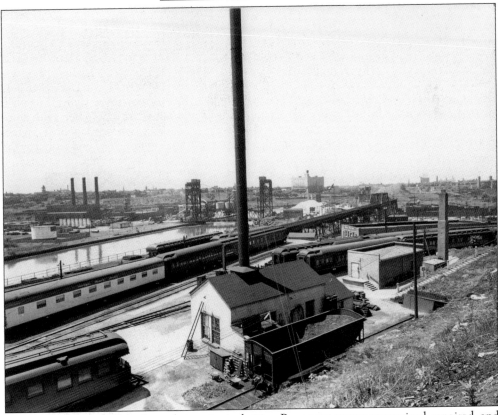

Railroads maintained coach yards in principal cities. Passenger cars were serviced, repaired, and readied for their next assignment. Usually located adjacent to a passenger terminal, the NKP's coach yard was at East Ninth Street near CUT. It had an office building, storehouse, commissary, and incinerator. In this image, there is a mixture of lightweight and heavyweight cars along with an NKP business car in the lower left-hand corner. (Cleveland State University Library Special Collections.)

Financial woes caused by lost freight and passenger business in the 1950s led many Eastern railroads to seek merger partners. The NKP feared the proposed merger of the PRR and NYC might leave it in a precarious competitive position. The N&W was seeking to extend its influence farther into the Midwest, which led it to seek a merger with the NKP, the Wabash Railroad, Akron, Canton & Youngstown Railroad, and the Pittsburgh & West Virginia Railway. The expanded N&W provided a conduit for freight between the Midwest and the Virginia Tidewater region. The merger was consummated on October 16, 1964. Trains with NKP motive power, such as the eastbound freight shown passing through Rocky River in the image above, gave way to trains such as the one shown below just west of Bunts Road in Lakewood. (Both, Cleveland State University Library Special Collections.)

106

Five

PENNSYLVANIA RAILROAD

The Pennsylvania Railroad (PRR) had just one route to Cleveland, but it was a busy one, hosting a steady procession of freight trains that served the region's steel and automotive industries. The PRR line had an active passenger operation until the 1960s.

The route began with the March 14, 1836, chartering of the Cleveland, Warren & Pittsburgh Railroad (CW&P), which intended to build from Cleveland to the Ohio River and connect with a railroad expected to be built from Pittsburgh. An economic downturn stalled development of the CW&P for nine years. Renamed the Cleveland & Pittsburgh Railroad (C&P), the company was reorganized by the Ohio legislature on March 11, 1845. The reorganization also changed the route from "the most direct in the direction of Pittsburgh" to "the most direct, practicable, and the least expensive route to the Ohio River, at the most suitable point." That point turned out to be Wellsville, Ohio.

In July 1847, contracts were awarded for constructing the railroad from Wellsville northward. Construction from Cleveland lagged until the C&P received an infusion of cash from the city of Cleveland. On April 18, 1853, the Pennsylvania Legislature approved an act incorporating the Cleveland & Pittsburgh Railroad Company and gave it authority to comply with all provisions of the C&P's Ohio charter.

The C&P was built to haul coal from eastern Ohio mines to Cleveland. But on June 24, 1856, the first boat carrying iron ore from Michigan's Upper Peninsula arrived in Cleveland, and the C&P was soon feeding iron ore to the growing steel industry of Northeast Ohio and Western Pennsylvania.

The C&P's freight business caught the interest of the Pittsburgh, Fort Wayne & Chicago Railroad (PFtW&C), which leased the C&P in 1862. The C&P crossed the PFtW&C at Alliance. Seven years later, the PRR leased the PFtW&C, forming the PRR's western extension from Pittsburgh to Chicago. The PRR then leased the C&P on December 1, 1871, for a period of 999 years.

Today, the former C&P is owned by Norfolk Southern Railway and is a key component of its route between Chicago and the Mid-Atlantic region.

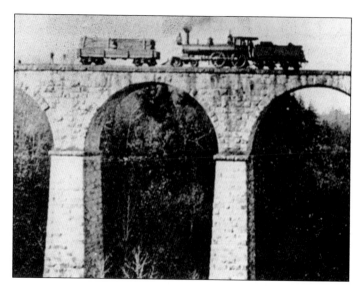

The C&P crossed Tinker's Creek in Bedford on a wood trestle. In 1864, the railroad built the stonemasonry arch bridge shown in this 1880 image. It was 100 feet tall and 200 feet long, and its arches were spaced 50 feet apart. The bridge was abandoned during a 1901 line relocation project, and fill was placed around it. The top of the bridge exists today in Viaduct Park. (Cleveland State University Library Special Collections.)

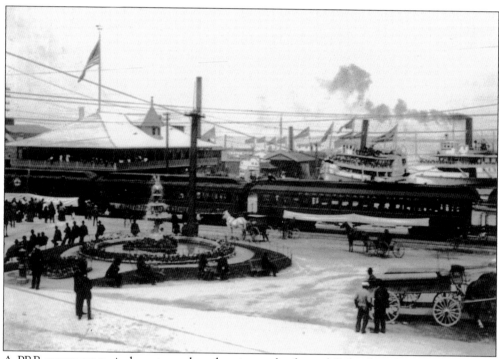

A PRR passenger train has stopped at the pier at the foot of Columbus Avenue that served Cedar Point boats. This may be a special train because it carries a banner reading, "Kilbourne & Jacobs Mfg. Co., Columbus, Ohio" on the side of a passenger car. Steamships shown are the *A. Wehrle, Jr.* (left) and the *Arrow*. Slightly visible behind the pier is the *R.B. Hayes*. (Cleveland State University Library Special Collections.)

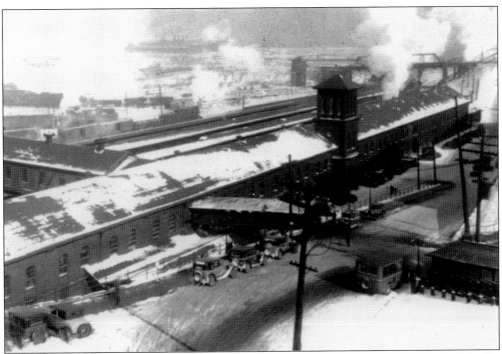

By the 1890s, Cleveland Union Depot had become a civic embarrassment. It was too small for the level of passenger traffic it served, and it appeared dingy and grimy. Someone placed a sign nearby imploring travelers not to judge Cleveland by its train station. Plans to replace it in the early 20th century were thwarted by World War I. All railroads serving the station, except the PRR, agreed to use the new CUT, which opened in 1929. The PRR remained at Union Depot until September 1953, when it began originating and terminating its Cleveland passenger trains at a station at Fifty-fifth Street and Euclid Avenue. Union Depot was demolished in 1959. In the image below, a PRR switcher works at the station in September 1950. A portion of Cleveland Municipal Stadium can be seen at right. (Both, Cleveland State University Library Special Collections.)

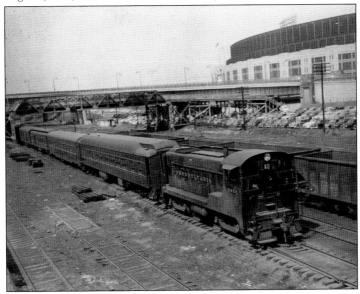

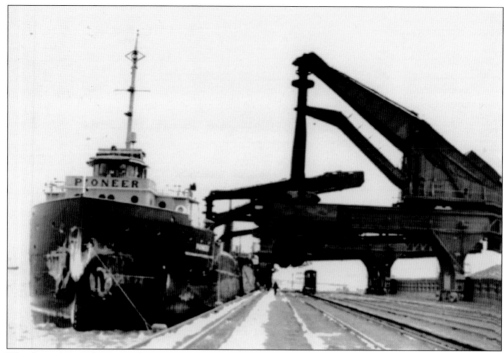

The June 24, 1856, arrival of a Lake Erie freighter hauling iron ore from the upper peninsula of Michigan began the long history of ore hauling by rail from Cleveland. As the steel industry in Ohio and Pennsylvania grew, this business boomed. The C&P purchased land on Whiskey Island near the mouth of the Cuyahoga River for an ore-loading facility. In the early 1900s, the PRR developed a new lakefront unloading facility that featured four Hulett unloaders. The Huletts used clamshell buckets to unload ore from boats. Cars were stored in an adjacent marshalling yard until they were ready for loading beneath one of the Huletts. The photograph above shows tracks leading into a Hulett unloader. The photograph below shows an overhead view of a Hulett unloading an ore boat. The Huletts were removed from service in 1992 and dismantled. (Both, Cleveland State University Library Special Collections.)

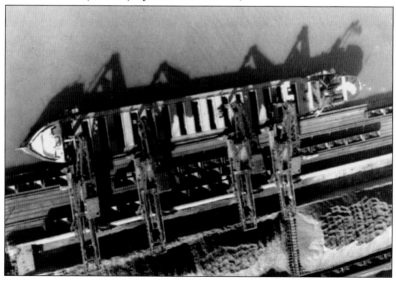

The PRR had one of the largest steam locomotive fleets in the country, and during the late steam era, it had more locomotives of certain types than some railroads had in their entire steam fleet. The PRR tended to develop specifications for locomotives and take those to a builder rather than relying on the builder to design a locomotive. Here, four locomotives are seen at Kinsman Yard in Cleveland. (Cleveland State University Library Special Collections.)

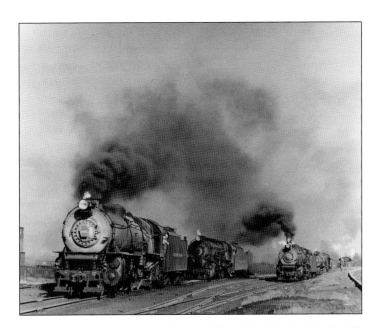

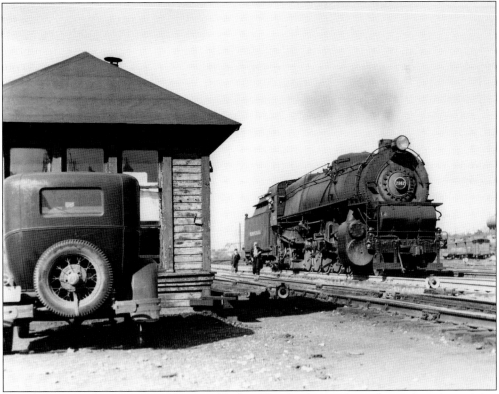

It might be crew-change time at Kinsman Yard in Cleveland, or perhaps the engineer is receiving instructions on what move to make next. No. 7247 is an N1s for PRR Lines West for drag-freight service, hauling heavy trains of coal and iron ore to and from Lake Erie ports. The PRR had 60 of this model, and all were built between 1918 and 1919. (Cleveland State University Library Special Collections.)

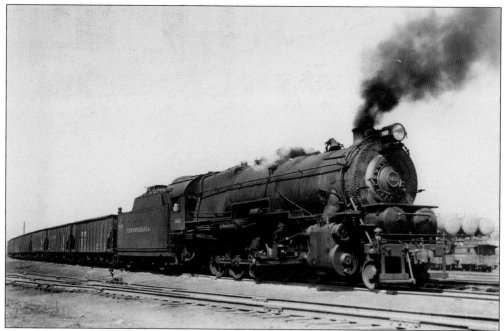

The C&P pioneered the use of coal for fuel in steam locomotives. Its first train pulled by a coal-burning locomotive left Cleveland in 1856, and coal soon supplanted wood as the fuel source for steam locomotives. The C&P was also a major hauler of coal from eastern Ohio mines to Cleveland industries and for loading on Lake Erie freighters. No. 3462, a 2-10-0 Decapod, hauls a train of hoppers. (Cleveland State University Library Special Collections.)

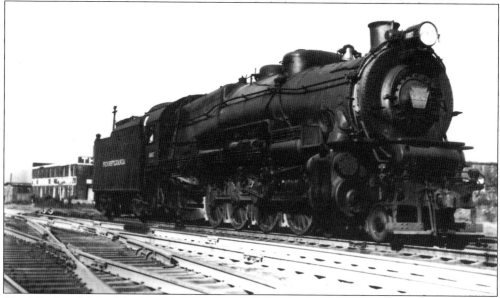

The M1-class 4-8-2 of the Mountain type that the PRR ordered for use on freight or passenger trains was most often used to pull fast freight trains. Because they could be assigned to passenger service, the M1 locomotives received keystone-shaped number plates. The PRR owned 301 of these locomotives, and some were still operating when the railroad phased out steam power in 1957. (Cleveland State University Library Special Collections.)

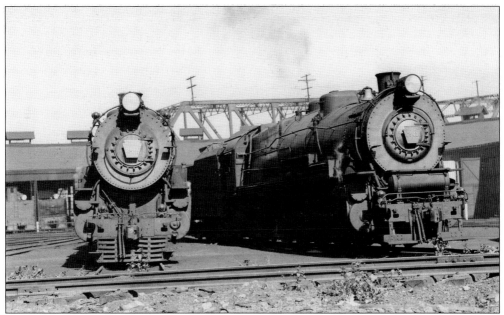

Kinsman Yard was the PRR's primary Cleveland classification facility. Located six miles southeast of downtown Cleveland, the 70-track yard classified merchandise freight. Situated on both sides of the mainline, Kinsman had a roundhouse and coal dock for fueling steam locomotives. Passenger locomotives serviced here were required to leave at least one hour before the scheduled departure of their train. Inbound trains received at Erie Crossing Tower a track assignment for working at Kinsman Yard. After the PRR merged with the NYC, Kinsman was closed by 1970, and all of the tracks and service facilities were removed. PC consolidated most Cleveland classification activity at the former NYC Collinwood Yard. Shown above at the roundhouse are Nos. 5461 (a K4s 4-6-2) and No. 6941 (a 4-8-2 M1). In the photograph below is No. 7472, a 2-8-0 H-class locomotive. (Both, Cleveland State University Library Special Collections.)

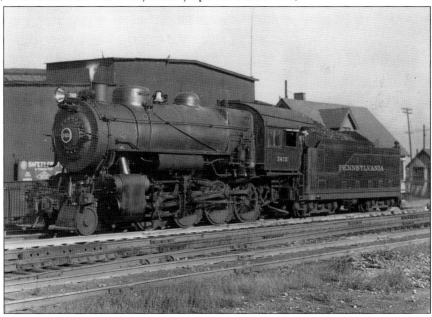

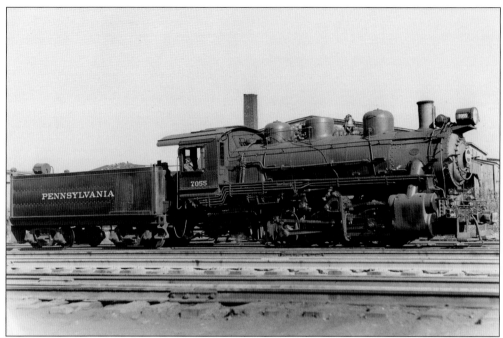

Most PRR Cleveland passenger service operated to Pittsburgh, although one train, the *Clevelander*, ran between Cleveland and New York with through sleepers for Washington, DC. Following World War II, the PRR upgraded its premier passenger trains, including the *Clevelander*, by giving them diesel locomotives and lightweight passenger cars. At the same time, the PRR spruced up two pairs of Cleveland-Pittsburgh trains, naming one pair the *Morning Steeler* and another the *Evening Steeler*. The budding interstate-highway system and airline competition ate into the PRR's passenger business in the late 1950s. By early 1960, the *Steelers* were gone, leaving the *Clevelander*, Nos. 38 and 39, as the last PRR passenger train in Cleveland. The *Clevelander* made its last Cleveland-Pittsburgh runs on April 25, 1964. A Cleveland-Youngstown remnant of Nos. 38 and 39 last operated on January 29, 1965. (Both, Cleveland State University Library Special Collections.)

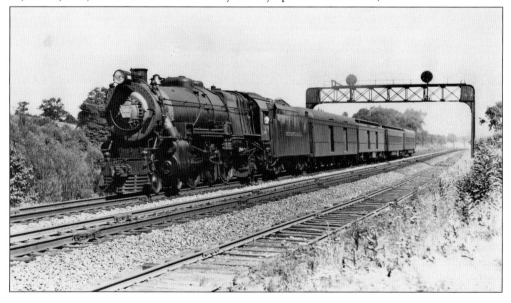

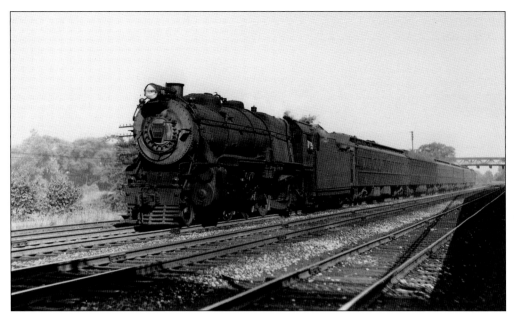

The K4s-class locomotive was the PRR's standard passenger locomotive. The PRR operated 425 of these Pacific-type locomotives, 349 of which were built in the railroad's Juniata shops in Altoona, Pennsylvania, between 1917 and 1928. K4s locomotives remained in service until the PRR ceased using steam locomotives in 1957. No. 8261 is shown leading a six-car train on the Cleveland Line in the late 1930s. (Cleveland State University Library Special Collections.)

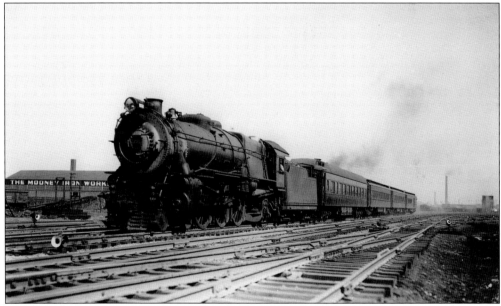

The PRR had two routes between Cleveland and Pittsburgh. Most trains operated on PRR rails via Alliance. However, some trains diverged at Ravenna and used B&O tracks to Niles Junction before getting onto the PRR's Ashtabula-Youngstown Line. Those trains made stops in Youngstown. The *Clevelander* operated via Youngstown, but the *Steelers* ran via Alliance. A four-car train is shown in Cleveland passing the Mooney Iron Works. (Cleveland State University Library Special Collections.)

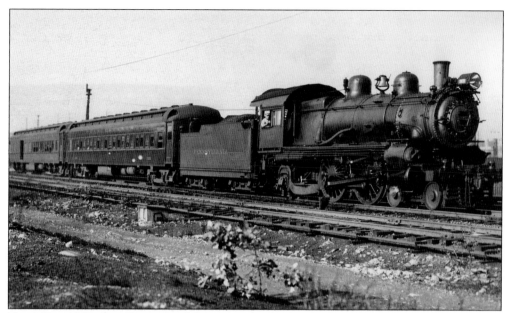

Nos. 252 and 253 were all-stops locals between Cleveland and Alliance that operated on commuter schedules. No. 253, shown on June 28, 1935, in Cleveland, departed Alliance at 7:15 a.m. and arrived in Cleveland just before 9:00 a.m. No. 253 was later renumbered and continued to run from Alliance to Cleveland until October 23, 1959. (Cleveland State University Library Special Collections.)

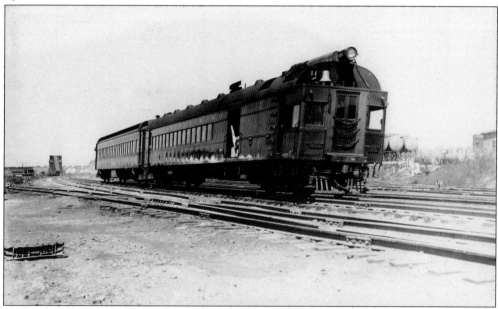

Beginning in the 1920s, some railroads assigned self-propelled passenger cars to lightly patronized branchlines. Nicknamed "doodlebugs," these cars used gasoline to turn a generator that sent electricity to the traction motors that propelled the car. The PRR used doodlebugs in shuttle service between Akron and Hudson, the latter being a stop for Cleveland Line passenger trains. A doodlebug with a trailing coach is shown in Cleveland on May 11, 1940. (Cleveland State University Library Special Collections.)

The PRR had a series of interlocking towers on its Cleveland Line that controlled the switches and signals at junctions with other railroads and at crossovers from one track to another. Shown at right is a portion of the interlocking machine used at Harvard Tower, which was located at the junction with the Newburgh & South Shore Railroad and the Wheeling & Lake Erie. This particular machine controlled the crossing of the PRR with the Erie. (Photograph by Craig Sanders.)

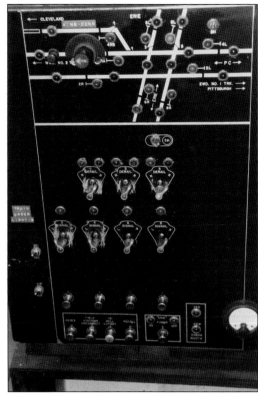

The PRR maintained a 15-track yard in Bedford in which to store empty hoppers and iron-ore jennies until they were needed at the ore dock on Whiskey Island. Farther south was Motor Yard in Macedonia, which was established in 1954 to serve a Chrysler Corporation stamping plant at Twinsburg and a Ford Motor Company stamping plant in Walton Hills. Shown is No. 7722, an 0-6-0 switcher. (Cleveland State University Library Special Collections.)

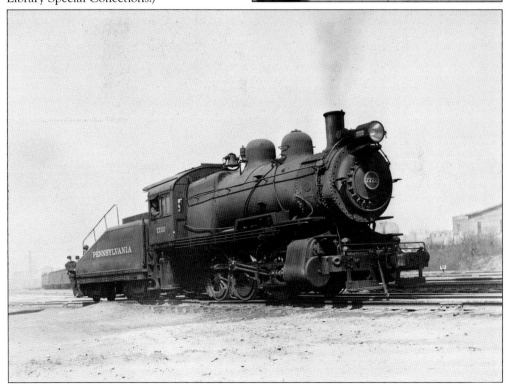

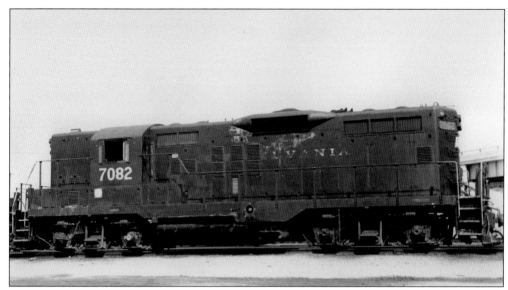

In the years before the PC merger, PRR diesels had a bare-bones appearance, with some newly delivered locomotives wearing little more than a number and PRR keystone logos. Gone was the attractive look of Tuscan red and pinstripes. Reportedly, this was done in anticipation of the merger with the NYC. In the photograph above, No. 7082 sports a rather plain appearance. This GP9 was built by EMD in 1956. The GP designation stood for "general purpose," whereas an SD designation meant "special duty." The GP models were often called "geeps." In the photograph below, it is July 13, 1968. The PC merger is barely six months old, and already this former PRR RS-11 has received its PC number of 7635. Built in May 1957, this locomotive wore No. 8635 before the merger. (Above, Cleveland State University Library Special Collections; below, photograph by Robert Farkas.)

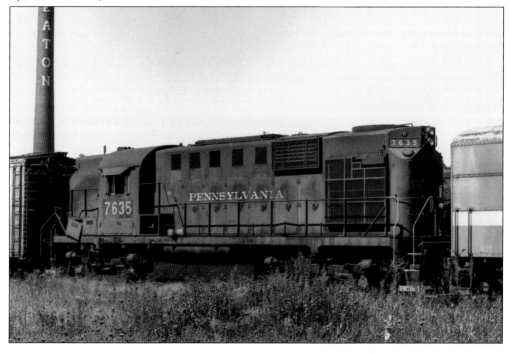

Six

WHEELING & LAKE ERIE

The history of the Wheeling & Lake Erie's Cleveland-Zanesville route goes back to the March 9, 1850, chartering of the Carroll County Railroad, which opened in 1853 between Carrollton and Oneida. After a host of financial difficulties and ownership changes, the railroad reached Canton on May 15, 1880, as the narrow-gauge Connotton Valley Railway (CV).

Two months later, the CV began building to Cleveland, reaching Bedford on July 4, 1881. Passenger service to Cleveland began seven months later after the CV completed a bridge over the Cuyahoga River. The CV entered Cleveland from the southeast near Calvary Cemetery and ran in a northeasterly direction, crossing Harvard Avenue; East Ninety-ninth, East Ninety-third, and East Ninety-first Streets; and Broadway and Union Avenues. It ran along the Cuyahoga River to a point near Ontario and Huron Avenues.

Most CV freight was coal delivered to the Cleveland Rolling Mill and Union Rolling Mill. The railway also operated a wharf along the Cuyahoga.

The CV began building south from Canton in 1882, reaching Coshocton in June 1883. An extension to Zanesville was completed in June 1889. The CV had been built with steel rails, not iron, that featured a generous amount of ballast, which drew praise from the Ohio Railroad Commission. The CV built a two-story headquarters and station in Canton, and the Stark County seat donated 46 acres of land on which the CV built locomotive and car shops.

The CV defaulted on its bonds in June 1883 and went into receivership. It emerged on May 9, 1885, as the Cleveland & Canton Railway. On November 18, 1888, the railroad was converted to standard gauge by 1,150 men. It later became the Cleveland, Canton & Southern Railroad.

In July 1890 the CC&S opened an eight-mile branch from Glenwillow to Chagrin Falls. Billing itself the Tip-Top Route, the CC&S fell on hard times when many Cleveland industries switched from coal to natural gas for their furnaces and boilers. The tracks and rolling stock of the CC&S deteriorated, with fewer than half of its 36 locomotives serviceable. The W&LE purchased the CC&S on August 5, 1899, and later moved its executive offices to Cleveland.

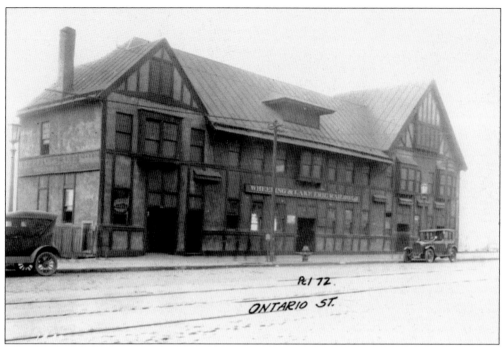

The CV's first Cleveland station was on Commercial Road. A permanent station opened on August 29, 1883, at Ontario and Huron Streets on a bluff known as Vinegar Hill that overlooked the industrial flats of the Cuyahoga River. To reach the station, trains had to twist their way up a wood trestle with the last half mile featuring a 1.6-percent grade. After that station was deemed unsafe, the W&LE spent $8,000 to build a "temporary" Tudor-style depot next door at 2260 Ontario Street. The photograph above shows the depot from the Ontario Street entrance. The depot, which opened on April 1, 1909, was about 1,000 feet from Public Square. The photograph below shows the interior of the depot. Passengers had to descend a stairway to board trains. The flier on the post advertises excursion trains to Wheeling, West Virginia. (Both, Cleveland State University Library Special Collections.)

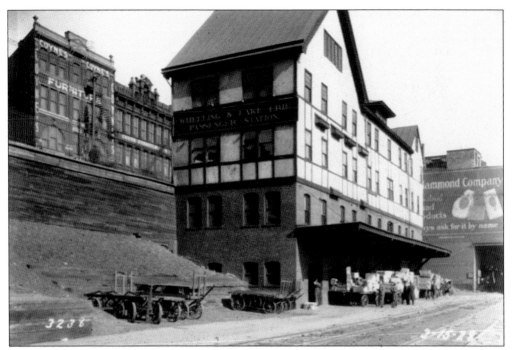

Above is a track-level view of the W&LE passenger station. The tracks curved to the right of the photograph. Note the door that opens into the freight house just beyond the station. A track led into the building, enabling boxcars to be loaded or unloaded out of inclement weather. The W&LE station stood on land that was needed for the east approach to the CUT. W&LE ceased using the Vinegar Hill depot on January 25, 1929, in favor of the Erie depot. However, the railroad opened its own station on Commercial Road on February 9, 1935, to save on rental fees for using the Erie station and track rental charges to use Erie and NYC tracks. The Vinegar Hill station was razed in April 1929, as shown below. (Both, Cleveland State University Library Special Collections.)

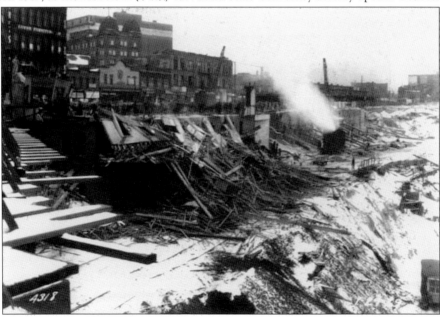

Nos. 32 and 35 were the W&LE's last passenger trains. They made a daily 304-mile round-trip between Cleveland and Wheeling. Although the original CV route had terminated at Zanesville, Ohio, service to that city had ended by 1932. At one time, there were three round-trips between Cleveland and Canton, but in 1932, the W&LE ended all passenger service except for Nos. 32 and 35. The image above shows the common consist of the trains, which usually were pulled by a 4-4-2 steam locomotive and had a baggage car, railway post office/smoker car, and an observation coach. Above, No. 32 is passing Garfield Park in Cleveland on May 24, 1935. Below, it is shown at the East Ninety-third Street, where the W&LE opened a station in July 1909 to replace another station at Jones Road. (Both, Cleveland State University Library Special Collections.)

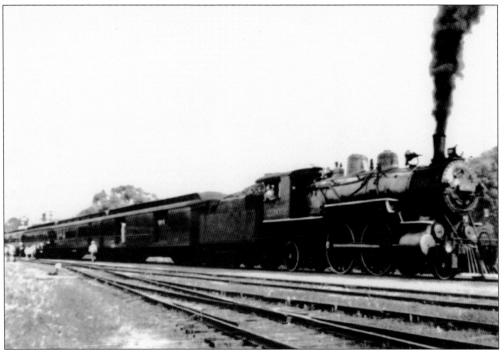

In the 1930s, the W&LE passenger fleet shrank to 11 cars and 4 locomotives. Nos. 32 and 35 averaged 6.15 passengers per trip. The Public Utilities Commission of Ohio in late June 1938 gave the W&LE approval to end these trains, and their last runs were made on July 17, 1938 (above). The Cleveland station sold 350 round-trip tickets at $3.05 apiece, and it was standing-room only after the 8:00 a.m. departure. Some 300 passengers paid a dime to ride across the Ohio River between Wheeling and Martins Ferry, Ohio. The photograph above shows the final trip, which had an expanded consist of five cars. No. 35 returned to Cleveland at 7:05 p.m., 15 minutes late. Pulling the last trip was Atlantic-type No. 2303. It is shown below in Cleveland on July 6, 1936. (Both, Cleveland State University Library Special Collections.)

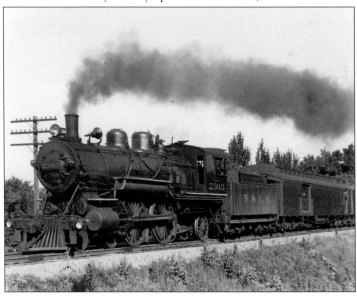

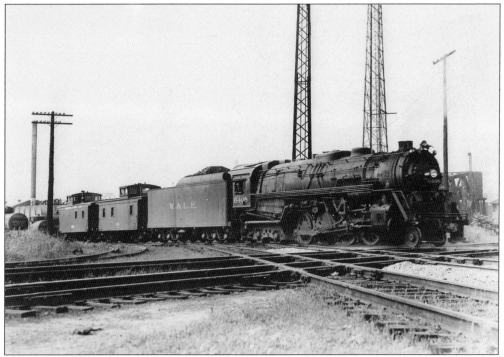

The W&LE's first K-1–class 2-8-4 Berkshire locomotives were delivered by Alco in April 1937 and proved to be just as adept at hauling high-speed merchandise freights as they were at handling slow coal drags. The W&LE eventually owned 32 of these locomotives. In this image, No. 6408 has a pair of cabooses in tow as it works in Cleveland in 1938. (Cleveland State University Library Special Collections.)

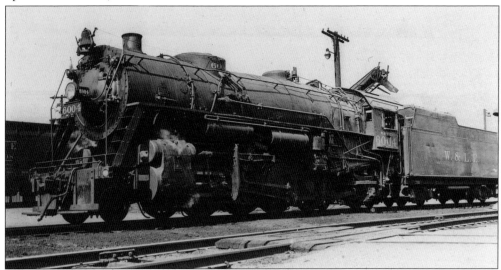

The W&LE used its 2-8-2 Mikado locomotives for a range of duties, from lugging heavy mineral trains to yard switching to pulling passenger excursions to baseball games. Based on a USRA design, the 20 locomotives in this class were built in 1918. The W&LE's Mikados enjoyed a long life, with the last one retired by the NKP in 1956. (Cleveland State University Library Special Collections.)

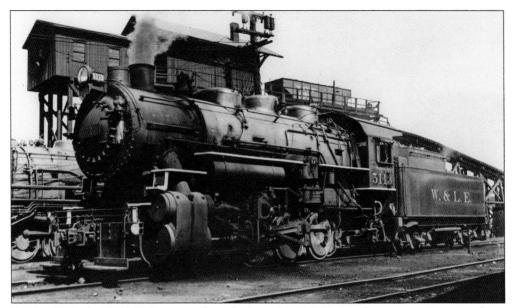

In May 1928, the W&LE's Brewster shops built its first 0-8-0 steam locomotive. Brewster shops built 20 of these switchers, including the 5113, which was completed on July 19, 1929. When released by the shops, the locomotives featured white paint on the main rods, driving wheel tires, running board edges, and poling pockets. Each unit also received a coat of gloss-black Duco paint and gold Delux lettering. (Cleveland State University Library Special Collections.)

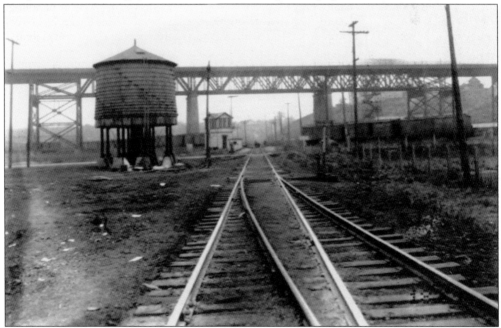

RD Tower was the junction in Cleveland where the W&LE's Belt Line branch crossed the B&O at a noninterlocked crossing. The Belt Line continued west to a connection with CUT at Knob. The bridge pictured here carries Dennison Avenue over the tracks. The tower is beneath the bridge. There, an operator controlled a target signal governing movements across the diamonds, and flasher signals at four nearby grade crossings. (Cleveland State University Library Special Collections.)

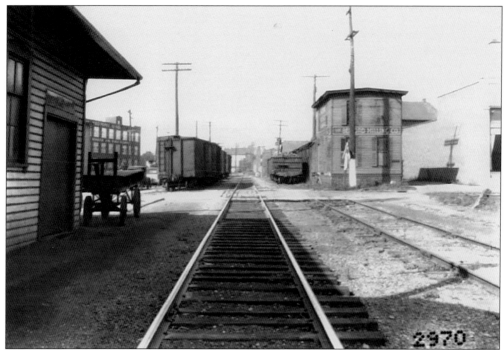

W&LE predecessor CV completed its line to Bedford, located 12 miles southeast of downtown Cleveland, on July 4, 1881. Until the institution of passenger service to Cleveland on February 21, 1882, CV passengers had to transfer to a C&P train at Bedford to reach Cleveland. The photograph above looks north from the 1882 Bedford passenger station (left). For a time, eight commuter trains operated between Bedford and Cleveland until this business was lost to streetcars and interurban railways. The photograph below is also looking north toward the passenger station. The building on the right above the tank car is the Bedford Town Hall, which dates to 1874. Both photographs show typical scenes along the tracks in the early 20th century, when oil companies and feed mills regularly shipped by rail. The Bedford depot is now owned by the city. (Cleveland State University Library Special Collections.)

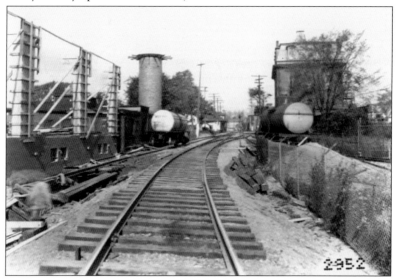

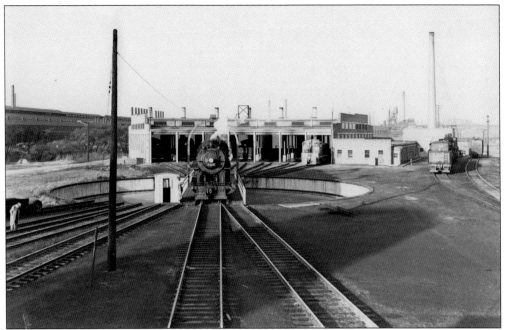

The W&LE built a yard at Campbell Road in Cleveland during the 1940s to replace the Mahoning Street Yard, also known as Coal Docks, that had been established by the CV on the west bank of the Cuyahoga River. The Campbell Road Yard featured the seven-stall roundhouse shown in both images on this page. Above, No. 6428, a 2-8-4 Berkshire, rides the 110-foot turntable in October 1949. Sitting in stall No. 7 is NW2 diesel D-2. The W&LE had just a handful of diesel locomotives, all of them switchers. To the right of the roundhouse in the photograph above is 0-6-0 No. 3977. Both photographs were taken shortly before the NKP leased the W&LE on December 1, 1949. Many W&LE steam locomotives continued to carry their W&LE markings through the early 1950s. (Both photographs by John D. Burger.)

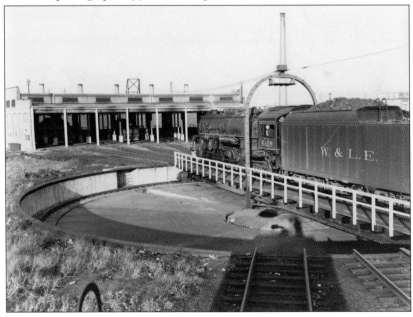

Discover Thousands of Local History Books Featuring Millions of Vintage Images

Arcadia Publishing, the leading local history publisher in the United States, is committed to making history accessible and meaningful through publishing books that celebrate and preserve the heritage of America's people and places.

Find more books like this at
www.arcadiapublishing.com

Search for your hometown history, your old stomping grounds, and even your favorite sports team.